KT-525-157 MANGA NOW! HOW TO DRAW ACTION FIGURES

Keith Sparrow

First published in 2014

Search Press Limited Wellwood, North Farm Road, Tunbridge Wells, Kent TN2 3DR

Text and Images copyright © Keith Sparrow 2014

Design copyright © Search Press Ltd 2014

All rights reserved. No part of this book, text, photographs or illustrations may be reproduced or transmitted in any form or by any means by print, photoprint, microfilm, microfiche, photocopier, internet or in any way known or as yet unknown, or stored in a retrieval system, without written permission obtained beforehand from Search Press.

ISBN 978-1-78221-078-8

The Publishers and author can accept no responsibility for any consequences arising from the information, advice or instructions given in this publication.

Readers are permitted to reproduce any of the items in this book for their personal use, or for the purpose of selling for charity, free of charge and without the prior permission of the Publishers. Any use of the items for commercial purposes is not permitted without the prior permission of the Publishers.

Suppliers

If you have difficulty in obtaining any of the materials and equipment mentioned in this book, then please visit the Search Press website for details of suppliers: www.searchpress.com

You are invited to visit: www.kaspar.co.uk http://keefsparrow61.tumblr.com www.facebook.com/keith.sparrow.1232

Printed in China

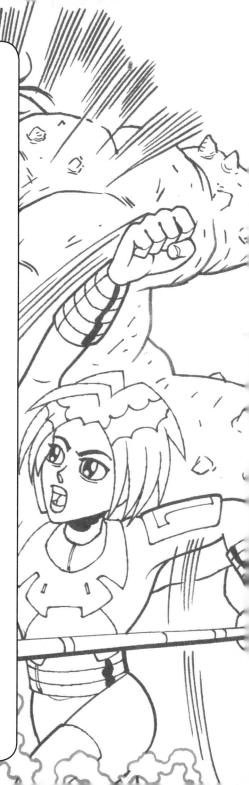

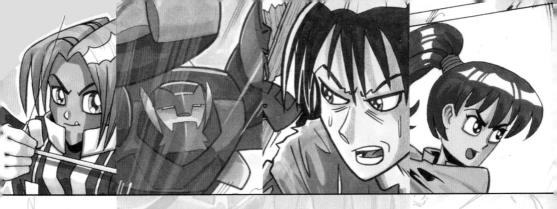

MANGA NOW! HOW TO DRAW ACTION FIGURES

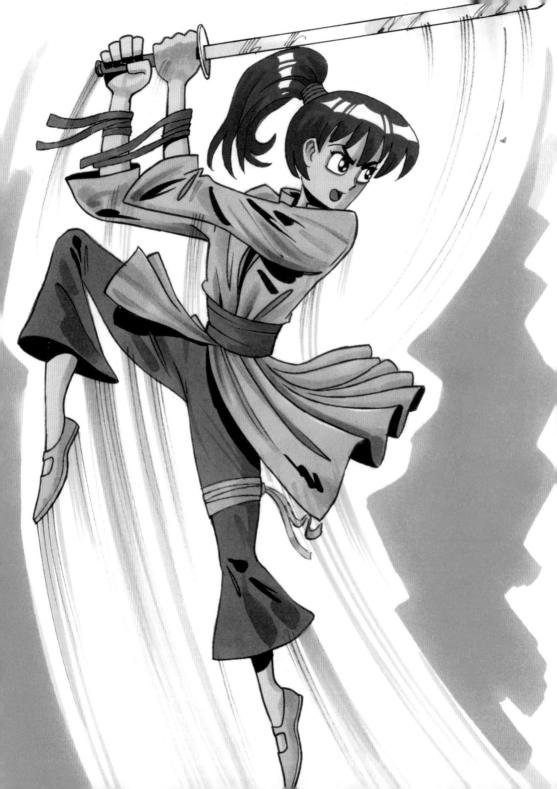

CONTENTS

		<u> </u>	6		N
Introduction	6		Let's Draw!		
Genres Ahoy!	10		Leaping Punch	44	
Space to Work	12		Shaman Spell	56	
A Material World	14		Hunted!	72	
Overcoming Fear of a	19		Swordplay	86	
Blank Page Reference It!	20	5	Sprint!	100	
Body Basics	20		Jumping Attack!	114	5
A Matter of Perspective	24	and	Ready For Action!	124	
Let's Face It!	26	Robertal	Get Your Kicks!	140	$\left \right\rangle$
Express Yourself	28	_	Slam Dunk!	152	1
Hair We Go!	30	2	Take Aim	168	
Show Your Hands	32	0	Don't Open		1
Fabrication	34		the Box!	186	5
Accessorise!	36		Surf's Up!	202	(here)
Light Stuff	38 40	No-araba	Mecha War!	218	
Special FX	40)	Full Speed!	234	
A MARIN	12	4	Heat of Battle	250	
N. A. T.P.	V		Break Out!	264	
S PELLER	2		Incoming!	280	
SV 417/2/	V		Index	286	
1 1/01			Glossary	287)
(V. / F)	1	d	- 5 12		
1 - 2 - 1	7	1 h	y of the	1/	

7

INTRODUCTION

Look, let's be honest here – if you've picked up this book because you already like drawing manga, or because you enjoy reading manga and want to start drawing your own pictures, then you probably already know all you need to about what manga is and what it isn't!

BUT IN CASE YOU'RE NOT SURE, WHAT IS MANGA? AND WHAT MAKES IT UNIQUE?

The simplest explanation is that the word 'manga' is used as a generic term to describe serialised graphic stories created and read in Japan. Of course, today they are also widely read in many other countries, and artists outside Japan create stories in a 'manga' style, or produce books designed to help aspiring manga creators (or *mangaka*), such as this one.

Japanese manga stories have a distinct graphic feel and tempo, which is very different to those produced in the USA or Europe. They usually start as serials in anthology titles such as the hugely popular weekly magazine, *Shonen Jump*. Readers are polled regularly to decide which strips they like most, and the most popular of these go on to be collected in separate volumes – the ultimate seal of approval is adaptation to an animated version, or anime. Manga can be an extremely competitive business, and mangaka are renowned for their devotion to their work.

The stories are mostly printed in black and white, with colour pages limited to covers, chapter headings or pin-up pages. The most successful may also have high-quality colour books published with pin-ups and character studies. If you're interested in life as a mangaka, there is an excellent series called *Bakuman*, by Tsugumi Ohba and Takeshi Obata, which explores the life of hard-working manga creators trying to make a successful series in *Shonen Jump*.

BE A MANGAKA!

SO JUST WHAT IS THE MANGA STYLE?

What most people notice straight away are the physical characteristics, such as over-sized eyes, dramatic spiky hair and lean, waif-like bodies, although these traits are not universal. Then there's the pace... stories evolve over a surprisingly long time, with space given to developing subtle emotional interactions and relationships. Also, strips are often peppered with graphic symbolism and sound effects to add dynamism and tension.

THE HISTORY OF MANGA

The origins of manga can be traced back to post-Second World War Japan, when the first modern manga anthologies began to appear. In the 1950s, the global obsession with science and technology was reflected in manga stories about giant robots and battle-suits, and this trend was exemplified by Osamu Tezuka's tale of a young robot boy, Tetsuwan Atom (Astro Boy). *Tetsuwan Atom* became the first animated TV series, or anime, with regular characters to make the jump from the pages of manga, and its visual style set the template for what we now recognise as the action manga look.

As manga became more and more popular, an ever-increasing number of mangaka experimented with stories about sports, such as boxing and baseball, science fiction robots and mecha-suits, gangster stories, traditional samurai warriors, magical girls, horror, romance and even the difficult subject of the nuclear bombs that were dropped on Hiroshima and Nagasaki at the end of the Second World War; in fact just about any subject you could think of was given the manga treatment, and sold in huge amounts in thick 200-page digest volumes known as *tankobon*, or the paperback-sized *bunkobon*.

KEY ACTION MANGA

Two of the most popular action-based series of the last few decades are Akira Toriyama's *Dragon Ball* and *Naruto*, by Masashi Kishimoto. *Dragon Ball* began in 1984, and told the tale of Goku, a boy who trained in the martial arts while searching the globe for the legendary Dragon Balls, mystic orbs with the power to summon a dragon that can grant a wish to the summoner. It established the idea of characters fighting in a series of tournament situations, something that has been used to great success in later series like *Pokémon* and *Yu-Gi-Oh! Dragon Ball* became a global success in manga and anime, and was a big influence on many up-and-coming mangaka.

Kishimoto's Naruto began serialisation in 1999 in Shonen Jump. Like Dragon Ball, Naruto features the title character in a seemingly endless series of battles as a developing ninja warrior; he discovers that he contains the spirit of the evil Nine-Tailed Fox, which was trapped inside his body when he was a baby. Naruto is, like Goku, a fairly comical character. The appeal of the series lies in its deceptive complexity, but also in its incredibly dynamic art style, which at times feels like it's about to burst off the page. As well as being a regular cover mainstay of Shonen Jump, Naruto has been a long-running anime series since 2002, and has crossed over into film, CDs, video games, trading cards and t-shirts, making it one of the most successful manga titles of all time!

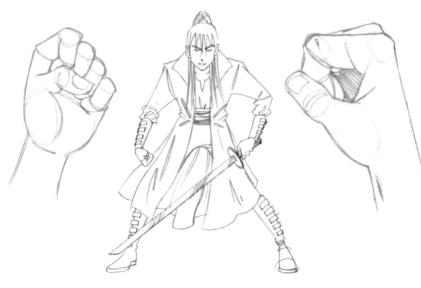

IT'S A MANGA WORLD

In recent years the manga style of art has become increasingly popular with artists and animators in the West, particularly since the hugely successful *Pokémon* brand. The name *Pokémon* is derived from the original Japanese brand, *Poketto Monsutâ* (Pocket Monsters). Originally a video game, *Pokémon* became a phenomenon in the gaming, toy, trading card, manga and anime markets, and introduced many Western readers to the basic principle of combat-style manga, where a multitude of characters with different abilities, skills or powers are pitted against each other in a never-ending struggle.

Another big influence has been the live action series Mighty Morphin Power Rangers. Produced in the USA, Power Rangers used footage from the Japanese series Super Sentai, and is a typical example of the mecha manga genre, with martial arts, giant robot battle-suits and hideous monsters all put together in a mad rush of colour and cartoon violence. Although not a manga, Power Rangers went a long way to develop a love of Japanese-style culture around the world.

The increasing popularity of manga and anime has led to a noticeable shift in the style of cartoons and comics outside Japan. Today, a quick glance at popular animated shows on children's TV demonstrates this influence quite clearly. Even the traditional superhero worlds of Marvel and DC comics have incorporated this style to a large degree, and manga-style versions of popular comics such as *Spider-Man* and the *X-Men* have also been created.

GENRES AHOY!

There are so many genres and sub-genres of manga that we'd need an index larger than this book to list them all! But here are some of the main types you may be familiar with:

SHONEN (OR SHOUNEN)

Action-oriented manga typically aimed at teenage boys, usually involving action and fighting, but often with a focus on teamwork and friendship or bonding. This is probably the most popular form of manga. **Examples:** Naruto, Dragon Ball, One Piece, Death Note, Yu-Gi-Oh!

SHOJO (OR SHOUJO)

Manga aimed at young girls, over ten years old. It covers a wide range of styles including magic, mystery, period drama and romance, often with an emphasis on emotional interaction between characters. **Examples:** Fruits Basket, Nana, Rose of Versailles.

MECHA

Tech-heavy manga featuring robots, weaponry and giant battle-suits, for example, sometimes with mystical overtones. It is often tied in to toy ranges. **Examples:** Mazinger Z, Gundam Wing, Patlabor, Appleseed.

SEINEN

Aimed at an older male readership of about 18–30 years old, it is darker in tone and more realistic than Shonen manga. Seinen stories deal with mature subjects, with less fighting and more focus on the interaction of characters. **Examples:** Akira, Ghost In The Shell, Chobits, Battle Royale, Maison Ikkoku.

MAGICAL GIRL (OR MAHOU SHOJO)

A sub-genre of manga dealing with stories about young girls who use magic. **Examples:** Sally The Witch, Sailor Moon, Tokyo Mew Mew.

SCHOOL LIFE

Stories mainly set in and around a school. **Examples:** Concerto, Wild Life, Black Bird, Tokimeki, Cromartie High School.

SPORTS

Manga stories set in the real world of popular sports such as baseball, basketball, football and tennis, where characters strive to develop skills and gain success in their sport.

Examples: Slam Dunk, Star of the Giants, Dokaben, Aim for the Ace!

MYSTERY

Manga featuring tales of unexplained events and subsequent crime-solving. **Examples:** Kindaichi Case Files, Spiral, Kamen Tantai.

SHONEN AI

Stories involving loving relationships between two boys. **Examples:** Challengers, Earthian, Kaze To Ki No Uta.

SHOJO AI

Stories involving loving relationships between two girls. **Examples:** *Gaia*.

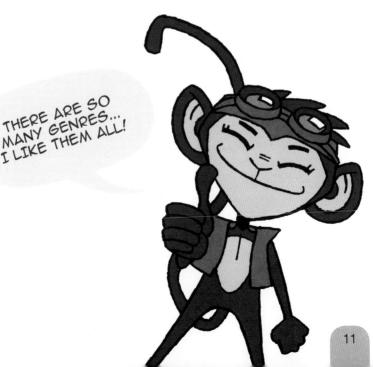

SPACE TO WORK

A very important factor in drawing, and one that is often overlooked, is a comfortable working space. If possible, you should find a table or desk that you can use exclusively so that your things won't get moved about. Maybe a desk in your own room, or perhaps part of the family kitchen table that could be designated as your drawing area. Once you have a space, try to keep it clear, clean and tidy when not in use. Use containers to store your pens, pencils and markers... you could use mugs or old jam jars, for example. If you leave an unfinished drawing on your desk it's a good idea to cover it with a piece of paper to keep it clean. Some people prefer a flat desk, some a sloping desk like a draughtsman's table – this is a personal choice. I prefer a flat space, but you can buy small adjustable sloping desktops if that suits you better.

YOUR LIGHT SOURCE

While you're drawing, make sure there's a good light source nearby. Drawing can put a strain on the eyes, especially in dim light, so if you're not near a window, or you're working at night, use a desk lamp. Some artists use 'daytime' bulbs, which have a blue tinge and more closely resemble daylight.

WHERE TO SIT

You also need to ensure you have a comfortable seat. Many people have bad posture when they draw, often hunched over a desk for hours on end... this can have a negative impact on your drawing technique, not to mention giving you back pains as you get older.

BREAK IT UP

Take regular short breaks and get up and move about, gently stretching your back if you can. Taking a break from drawing is also important for your eyes – staring closely at a drawing for long periods of time can quickly lead to tired eyes, so changing your surroundings now and then is good for them, and will also help to keep your mind fresh.

MY CREATIVE ENVIRONMENT

Here's a photo of my drawing space, showing a variety of tools and equipment. Notice the drawers on either side for storing reference materials and other tools.

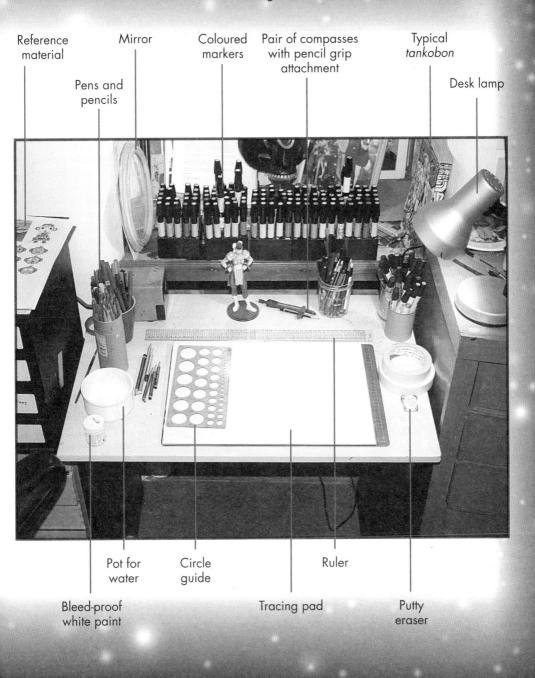

A MATERIAL WORLD ...

As for any other job, to get the best results you need the right tools. Those tools will vary from artist to artist, and what works for you may not work for the next person. So how do you choose? Simple: TRIAL and ERROR.

PENCILS

A pencil is an essential tool for any artist, but don't try to draw with a blunt pencil you found at the bottom of a kitchen drawer - invest in some quality pencils. There is a range of pencil grades from hard (H) to soft (B) - the hardest is 9H, through to the softest at 9B. In the middle you have an HB and an F grade (midway between H and HB). A very hard pencil gives a cleaner line but tends to cut into the paper and is not suitable for non-technical drawing such as manga. On the other hand, a very soft pencil can smudge easily and can quickly lead to a very messy sketch! The best place to start is in the middle, with an HB grade. This will give you a reasonably clean line but is soft enough to allow for some flexibility in your drawing. Use a softer grade such as a 2B or 3B to add some shading once you have the basic drawing in place. It's worth paying slightly more for a good-quality pencil, rather than the cheap ones you can buy in bulk. Don't be afraid to go to your local art shop and ask for advice on which brands of pencils to try. There are lots to choose from and it's worth trying a selection to find the one you're most comfortable with. You will be constantly sharpening your pencils, and inferior brands often fracture along the lead and become useless. Make sure you have a decent pencil sharpener – if possible get an electric one; you will be using this a lot, as a sharp point is essential to good drawing.

ERASER

As you work on your drawing you will sometimes need to erase a line or two. Make life easy for yourself by not pressing too hard when using your pencil... it's a lot easier to clean up a light drawing! Later, when you've inked your drawing you will also need to erase unwanted pencil marks, especially if you want to colour it.

Erasers are available in all shapes and sizes, but you should avoid novelty types as they can smear your work and leave lots of bits behind. Plastic and rubber erasers can also be quite messy and can damage your paper surface with heavy use. I tend to use putty erasers, which don't tend to leave any mess behind and are quite safe on paper. You can buy them in any high street art shop.

PAPER

Choice of paper is also important. There are lots of styles and colours: smooth, rough, white, off-white, and you should experiment with as many as you can. Local art shops may have some samples you can try – you could be a future regular customer to them so don't be afraid to ask. The paper you use will depend on how you want to finish your drawing and whether or not you want to colour it.

To start with I would suggest buying a cheap cartridge paper sketchbook to practise in so that you won't be afraid to make mistakes or take chances with your drawing. Cartridge paper is a very comfortable and strong surface and will take coloured pencils well if you wish to try those. If you intend to ink your drawing (using an ink-based pen or brush to finish off your pencil sketch) you should use a smoother, high-grade paper. You will find pads of suitable paper in your art shop, some actually branded as 'manga paper', which are good for clean linework, but any smooth surface paper will do. Marker or layout pads are very good if you intend to colour with marker pens, as many manga artists do.

Another option is to do your pencil drawing on one sheet of paper, then trace over the linework on a separate sheet, leaving you with a clean, pencil-free version to colour in. A desktop lightbox is very useful for this method.

INKING & COLOURING

When you're happy with your pencil drawing, the next stage is to ink and colour it. There is a multitude of ink pens, brushes and inks you can use – it's worth having a look in your local art shop, where you can usually try them out before buying.

Pens come in grades of nib thickness, from 0.1mm up to 0.8mm and above. A good starting point is a medium-size nib, such as 0.5mm. It's also worth thinking about how you will use different pens within your drawings: you might want to use a thicker pen for the outside line of a figure and for objects in the foreground, and a finer pen for smaller details or background objects, as this will give your drawing a sense of depth. As well as regular pens there are brush pens, which can be useful for lines of varying width – from very fine lines to broad brush strokes – or for putting in strong shadows. These are normally cartridge pens with a brush tip instead of a nib.

When you've inked your drawing, let it dry completely before erasing any unwanted pencil marks. You can colour your drawing using a number of different media, such as colour pencils, markers, paint, or on the computer.

Colour pencils

The simplest way to colour your drawing is with colour pencils. These are relatively cheap and come in an excellent range of colours. As with all things, it's well worth paying a little bit more for a quality set, and don't forget to keep a reasonably sharp point on them.

Markers

Probably the most common medium for budding mangaka is coloured markers. They come in a wide range of colours and shades of grey, and can be blended and combined to excellent effect. Most are double-ended, with a broad, wedged tip at one end and a thinner, rounded tip at the other. Some also have a third, fine-line tip. These markers can take a little getting used to but are very versatile. Their downside is that they aren't very practical for small details, as the colour tends to 'bleed' out from the point of contact with the paper surface.

Paint

Some artists like to use paint such as watercolour on their manga art. With a bit of practice this can be a lovely way to give your art a vibrant look. You must ensure you use a waterproof ink to do your linework, which should be drawn onto a smooth watercolour paper – use a desktop lightbox if you need to trace your outline.

White-out paint

Whichever method you use to colour your drawing, it's worth also having a small thin brush on hand with a pot of white bleed-proof paint – this is handy for cleaning up any linework mistakes or tidying up colour that has bled through the linework. Keep a pot of water nearby to wash your brush immediately after use. When paint dries on the brush it can be hard to remove without damaging the bristles.

Computer

If you're familiar with computer programmes such as Adobe Photoshop, you can achieve some fantastic results by scanning in your linework – or even drawing it straight onto the screen if you use a tablet – and colouring it in digitally. The advantage of this is that you can easily create special effects and gradients, as well as being able to edit and change your drawing. Scan your linework in at high resolution (at least 300dpi), clean it up, then increase your contrast to 100 per cent, adjusting the brightness as needed. Then you can select areas of your drawing to colour. It's a good idea to duplicate your linework layer in case you go wrong, and make sure you save at regular moments. You don't want to spend hours on a piece of artwork and then lose it if your computer crashes!

RULERS AND DRAWING AIDS

iB

14 15 16

20 21 22 23

11/111

Sometimes you will need perfectly straight lines or neat curves in your drawing. Manga is renowned for its painstakingly accurate depiction of things such as streets, buildings and cars, so to get your drawing as accurate as possible you should have a clear, sturdy plastic ruler for straight lines, and a circle guide and small pair of compasses for curves and circles. All of these can be bought from stationery or art shops. Think about how big your workspace is and don't buy a ruler that's too long for practical use – if it's too long you'll find yourself always knocking pens off your board when you change angles – very frustrating! I find that a 30cm (12in) ruler is usually sufficient for most straight lines.

Circle guides are plastic templates with a variety of circle sizes cut out, but for larger circles you should use a pair of compasses. Remember not to press too hard into the paper with your point though – gently but firmly is the rule here. I prefer to draw curved lines freehand, but if you're not confident doing this you can buy plastic curve templates in a variety of shapes, or use flexi-curves, which can be bent to any degree of curve you want.

OVERCOMING FEAR OF A BLANK PAGE

The best thing about drawing your own manga, or drawing anything for that matter, is that YOU MAKE THE RULES! No one can tell you what you should or shouldn't draw: it's completely up to you.

The trouble is – as any self-respecting superhero will tell you – with great power comes great responsibility. If no one tells you what to draw, how do you know where to start? What I have learnt, is that the only way to conquer the fear of a blank space is to begin to FILL IT! Once you break the spell of an empty piece of paper you'll find it gets easier with every stroke of the pencil. Doodling is a very useful way to do this, and with doodling you can let your mind wander while you ponder the possibilities in front of you. Keep well away from the main area of the paper and limit yourself to the margins; all manner of ideas may actually evolve from the tiny marks you make.

Another way to combat the blank space is to draw random lines, shapes and curves in big swathes across the page. Keep it light enough to erase if need be, and once you've made a few marks you can begin to construct your image using those lines as a kind of very rough plan. Treat the blank space as an enemy in combat: treat it with respect and caution, but don't fear it and you won't go wrong.

REFERENCE IT!

Any professional artist will tell you how useful it is to use reference material as part of your drawing technique. Although you can draw what you want, how you want, it's a good idea to do a little research into the real world.

WHAT TO LOOK FOR

If you want to draw an imaginary vehicle, you can make it more believable by looking at how a real one is constructed. Where does the driver sit? How do you steer it? How does it move along – on wheels or through the air? If you look at pictures of real cars or aeroplanes, you can see where the driver or pilot should sit, how the weight is distributed between the wheels or wings, and imagine how it might be powered. If it has an engine, does it need exhaust pipes? Would the engine be visible on the outside of the vehicle, or hidden under a smooth body? It's up to you how it looks but thinking about the answers to these questions lends authenticity to your art.

In the same way, if you draw a weapon such as a sword or a gun, you can make it much more dynamic by looking at references of how a gun or sword is held – how do the hands grip? What does it do to the shape of the arm and how does that work in relation to the body? Would it be held close to the body or at arm's length?

> KEEP A SMALL MIRROR BY YOUR DRAWING SPACE - USE IT TO HELP DRAW FACIAL EXPRESSIONS AND HAND SHAPES.

ASK YOUR FRIENDS OR FAMILY TO POSE FOR REFERENCE PHOTOS, WHICH YOU CAN USE AS GUIDES TO POSTURE AND CLOTHING WHILE DRAWING. THEY MAY BE SLIGHTLY EMBARRASSED AT FIRST BUT IT'S A LOT OF FUN AND REALLY USEFUL!

WHERE TO FIND INSPIRATION

These days it's easy to find all the reference material you need with a quick search on the Internet. If you have a printer you can print off useful images and have them by you as you draw. If you don't have access to a computer, your local library will have lots of books you can take home to study at your leisure. Another good tip is to visit your local charity shop or boot sale for bargain books – you will find all kinds of great reference books, and very cheaply!

Another good way to improve your drawing is to look at your favourite manga and see how the artist works. There's no shame in practising your drawing by copying a good artist whose work you admire. Most artists will admit to copying drawings at some point in their career – the important thing is to move on and develop your own style. And this can only be done by drawing... lots and lots of it!

BODY BASICS

Okay, let's imagine we have a good set of drawing tools, a clean sheet of paper, and we're sitting in a comfortable position at a tidy, well-lit table. Where shall we begin?

CREATING WIREFRAMES

At their most basic, manga figures can be broken down into a simple series of connected circles and triangles, known as a wireframe. Once you understand how the shapes relate to each other, you can draw figures in any position you like, simply by using this basic construction method. Let's look at a male figure, for example:

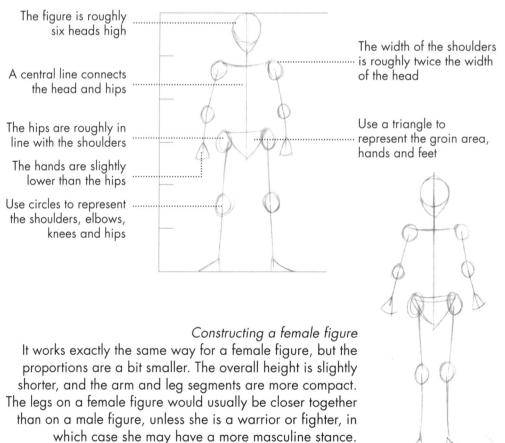

FLESHING OUT YOUR FIGURES

The ribcage should be broader than the waist

The arms and legs go in and out slightly to show muscle

The hands are drawn with palms backwards so his thumbs would be pointing inwards

The thighs are broader than the calves, which slope in to a --narrow ankle on top of the foot

> Breasts are roughly circular and join on the centre line

The waist goes in further than on the male, to give a more curvy shape to the body

...... The palms are facing forwards, so the thumbs are pointing away from the body

... The hips are wide in relation to the waist

--- Muscle masses on the arms and legs

A MATTER OF PERSPECTIVE

It's important when you're drawing action manga figures to use interesting viewpoints to keep the viewer engaged. Varying the perspective can add dynamism to your drawing, and it's not as difficult as you might think. If you stand on a chair and look down on someone you'll see how it works.

THE VIEW FROM ABOVE

I like to start by creating a rectangular threedimensional box as seen from above. Draw two diamond shapes, one above the other, and connect the corners with straight lines. Notice how much larger the top diamond is than the bottom one: even though they are different sizes, they create the illusion of being the two ends of one shape.

ଚ

Sketch a wireframe figure inside the box – draw in the head at the top and the feet at the bottom first. Bear in mind that you are looking at the figure from above: the head needs to be much larger than the feet. Connect up the rest of the body – the limbs will look much shorter from this angle than they would from straight on.

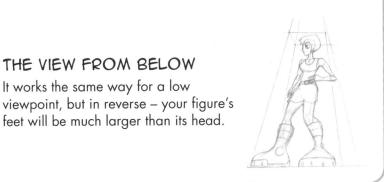

THE VIEW FROM BELOW It works the same way for a low

feet will be much larger than its head.

4

Flesh out the figure. The facial features should be in the lower part of the face, with the neck concealed by the head.

Finish off the sketch by adding details such as hair and clothing.

IT'S A BIT LIKE STANDING IN A LIFT!

LET'S FACE IT!

Of course, every face is individual and unique in its own right – that's what makes humans interesting! – but as with everything about drawing manga characters, there are some simple rules you can follow. We'll look at different facial expressions and hair styles later in the book – for now let's focus on getting the proportions right.

CONSTRUCTING A FACE

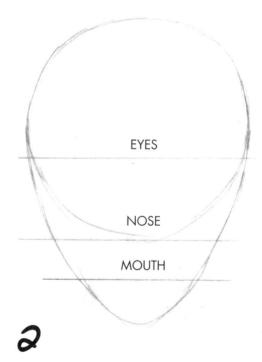

The basic shape of the head is a bit like a balloon, or an egg. Start by drawing a circle, then add on an elongated curve underneath: this forms the lower jaw and is where you will put the nose and mouth. Draw a horizontal line across your circle, just over half way down; use a ruler to keep the line straight and only draw lightly in pencil so that you will be able to rub out the marks later. Bisect the lower half, then do the same with the bottom quarter. These three lines show you where to draw in the eyes, nose and mouth. Even though manga characters have very exaggerated features, such as larger than normal eyes, tiny noses, and thin-lipped mouths, you should still check your own expression when you're drawing. Keep a small mirror handy: if you want an angry face, for example, practise grimacing or snarling into the mirror so you can see how it alters your features.

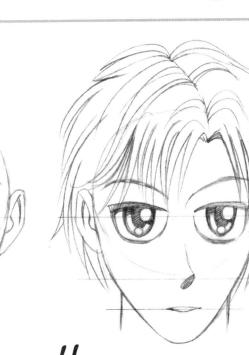

3

Sketch in your character's features. The ears should be roughly in line with the eyes. Eyes are often large and expressive in manga, whereas noses and mouths are just the opposite! Female faces are constructed in the same way as male faces but with smaller proportions. The chin is often more pointed, the nose smaller and the eyes wider and deeper.

4

The final stage is to add hair. The style shown here is a loose, floppy style often seen in manga, with lots of individual strands that add detail and interest. There is a parting on one side, and you can see how the hair stems from this line. Remember that the hair grows up out of the head before it falls down onto the face and behind the ears.

One of the most effective ways to tell a graphic story is through facial expression - that's how we read each other's emotions; how we know if someone is happy or sad, surprised or angry. Look at this range of emotions: notice how the eyes and mouth change shape in response to the character's emotions.

MALE FACE

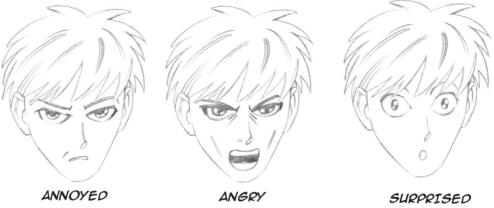

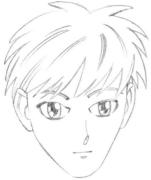

COMPOSED

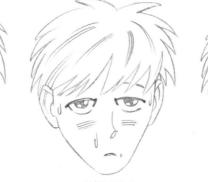

HAPPY

FEMALE FACE

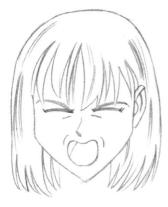

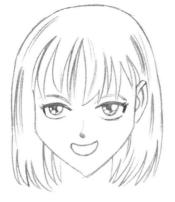

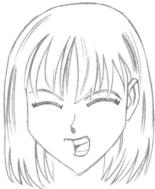

IN PAIN

PLEASED

SHOUTING

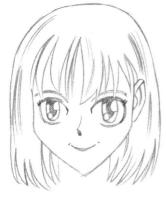

OPTIMISTIC

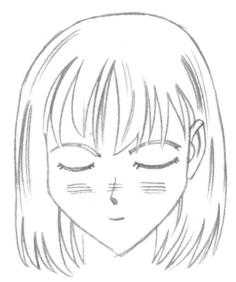

EMBARRASSED

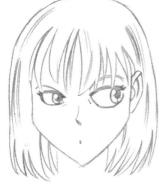

SUSPICIOUS

HAIR WE GO!

Hair styles are a great way to distinguish one character from another. There's often not a lot of difference between male and female styles, so here's a few ideas to get you started.

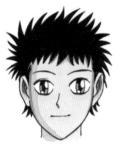

SHORT & SPIKY

Lots of short, soft spikes – this style is ideal for boys or girls.

LONG FRINGE BOWL

Bowl cut with spiky, asymmetric fringe falling down over the eyes. Useful for boys or girls.

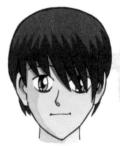

STIFF SPIKES Angular, bold spikes, typical of a young male action hero.

LONG SHAGGY SPIKES

Short fringe over the eyes, long spikes on top of the head and long at the back. Ideal for boys or girls.

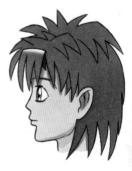

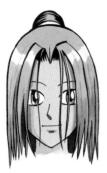

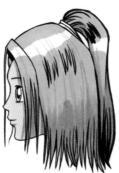

LONG & STRAIGHT WITH TOPKNOT

A long fringe overhanging the face with long straight hair and a topknot. A modern version of a traditional Japanese style. Could be used for boys or girls.

TWIN PONY TAILS

A common style for young female characters in school settings.

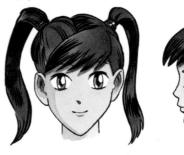

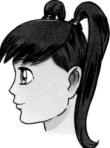

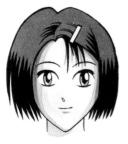

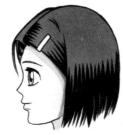

BOB WITH PARTING

Girl's standard short bob cut with a parting and a hair grip.

EYE-LEVEL FRINGE

Shoulder-length straight hair that flicks out at the bottom, and a straight, eye-level fringe.

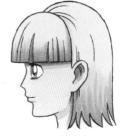

SHOW YOUR HANDS

The hand can be a tricky thing to get right, but once you understand the basic construction it's as easy as A-B-C.

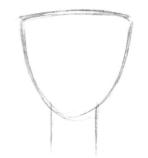

For a relaxed hand with the palm facing forward, draw a shape a bit like a goblet or egg cup, with a thick stem. This will form the palm of your hand and the wrist.

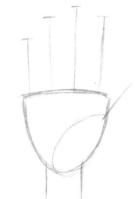

Draw four evenly spaced vertical lines to form the fingers. The index and third finger are the same length, the middle finger is longer and the little finger is shorter. Add an oval shape and a line at an angle to indicate the thumb.

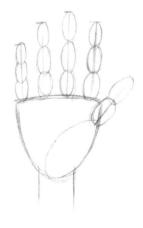

4

Outline your shape. Note how the outline flows in and out around the segments of each finger. The thumb is drawn sideways on, so is smoother on the outer face.

3

The fingers are separated by the knuckles into three roughly even segments. Draw these in as oval shapes. The thumb should have two equal-sized segments, as shown.

USEFUL ACTION HAND SHAPES

When drawing wireframes for other hand positions, use your own hands as a guide to help you visualise the joints.

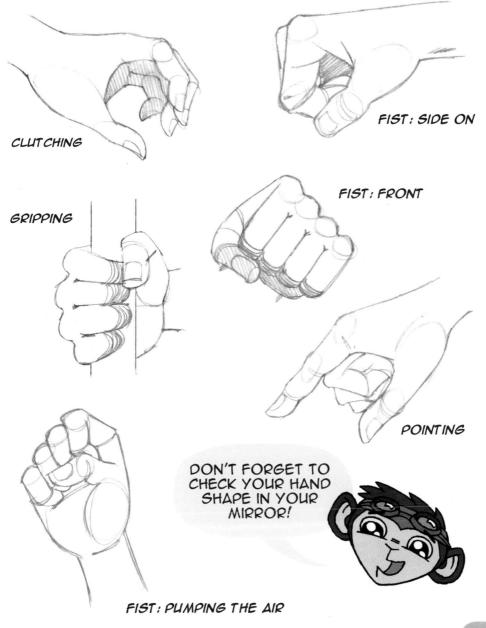

FABRICATION

Dynamic folds and ripples in costumes can make your figures come to life! Here are two different examples of how loose fabric works with the body: a sword-carrying prince and a sharp-suited businessman...

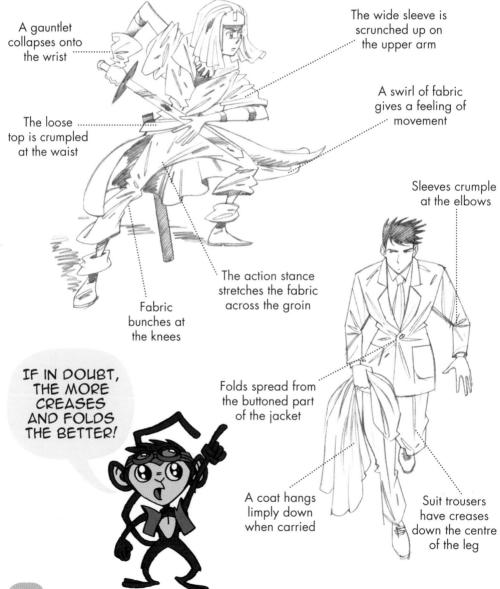

EVERYDAY ITEMS

Here are some more folded and creased items of clothing. I've drawn them with a brush pen and added some loose grey marker to give some interest and depth. Practise lots of examples in different positions to build up your confidence.

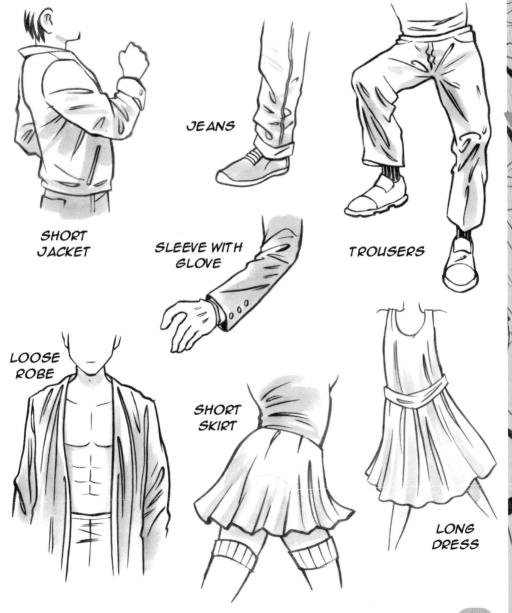

ACCESSORISE!

As well as clothing and hair styles, you can use a whole variety of weird and wonderful accessories to individualise your action characters. These can be based on real objects or could be creations from your imagination. Here are a few examples to get you thinking...

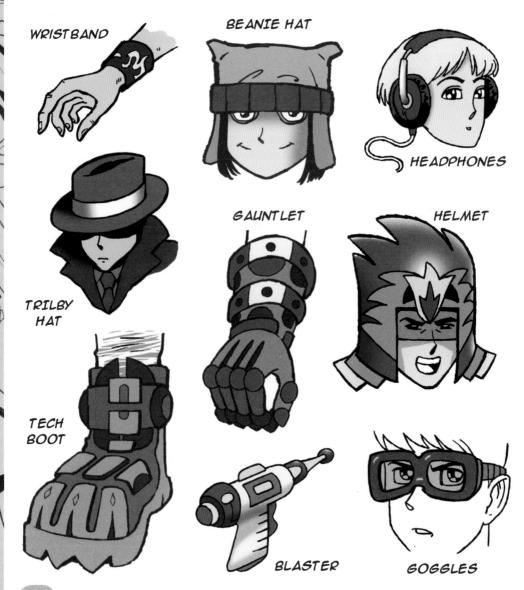

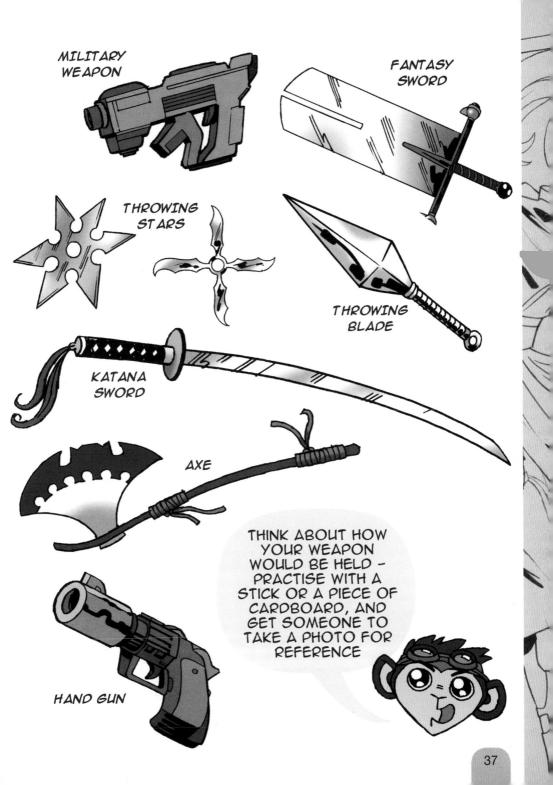

LIGHT STUFF

Light and shade are vital parts of an action manga drawing, particularly as the vast majority of manga is printed in black and white. It's important to know where your light source is and what effect it has on your figure. Let's look at a basic character, like this swordsman, lit from four different directions.

CHANGING THE LIGHT SOURCE

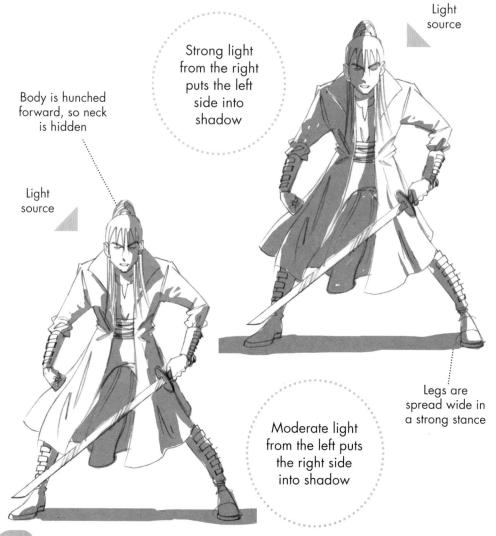

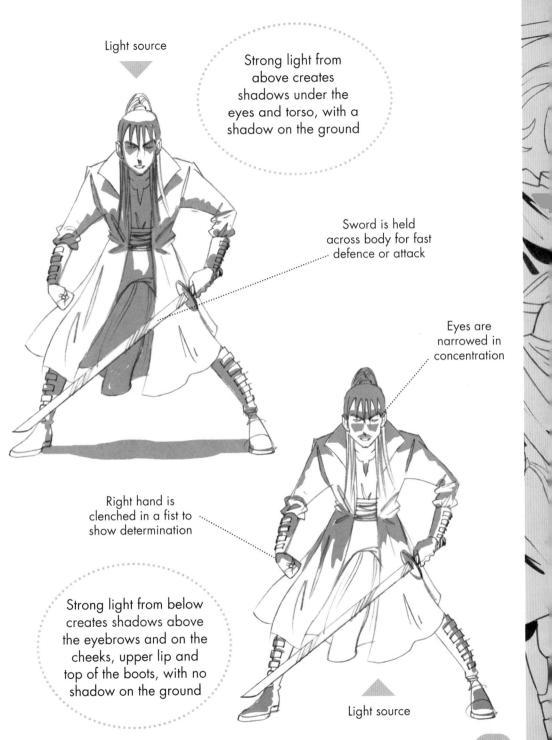

SPECIAL FX ...

Manga is full of graphic symbols and techniques that make it unique. Here are a few of the most common, which you can add to your drawings. It's a bit like having a special language that all manga readers learn to speak...

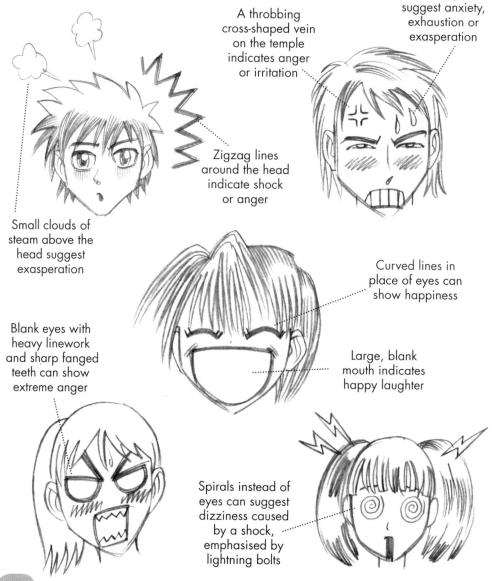

Sweat drops can

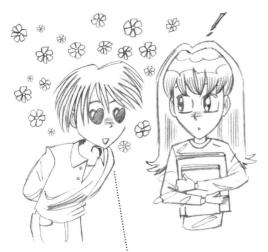

If someone is about to cry you may find these small circles appear in the bottom corners of their eyes

When a character is feeling romantic his or her eyes may turn into hearts and small flowers or petals may appear floating around them. In more traditional manga these can turn into full blossoms sprouting on branches

> Speed lines are frequently used to show movement

> > A variety of speech and sound bubbles can be used for exclamations, thoughts and sound effects

> > > WOOOH!

Irregular panel shapes are used to make the manga page more dynamic I THINK

50

PATTLE

LET'S DRAW!

The first rule of drawing is that you must not be afraid to MAKE MISTAKES. With every error comes learning, and with learning comes improvement. When you begin your drawing it's a good idea to sketch loosely in pencil. The lighter your initial sketch the better – this will make it easier to erase lines at a later stage. Build your drawing slowly, using stronger lines as you find the shapes you're happy with.

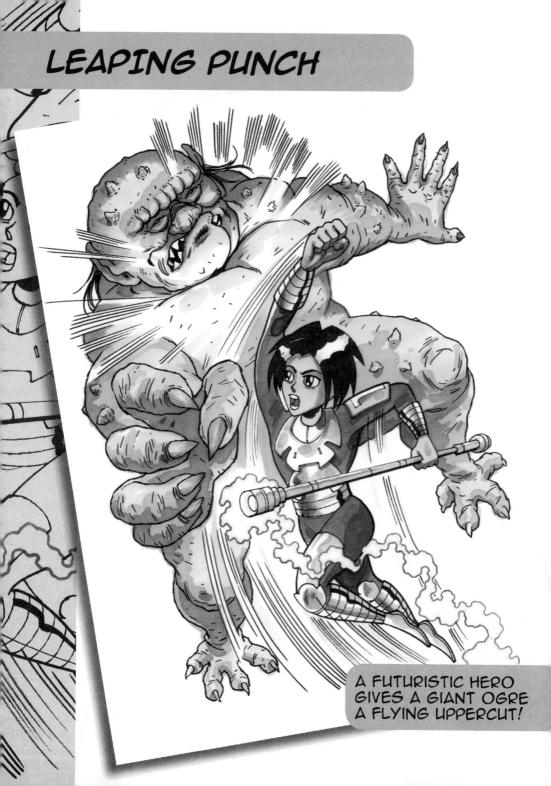

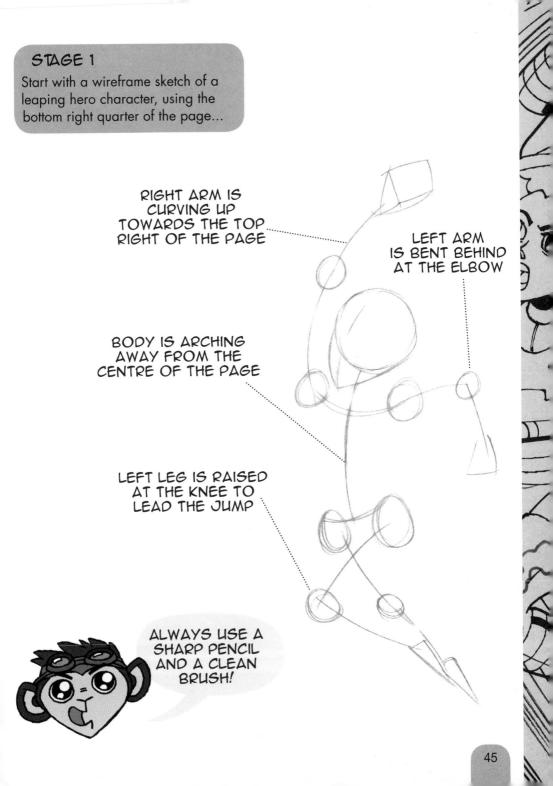

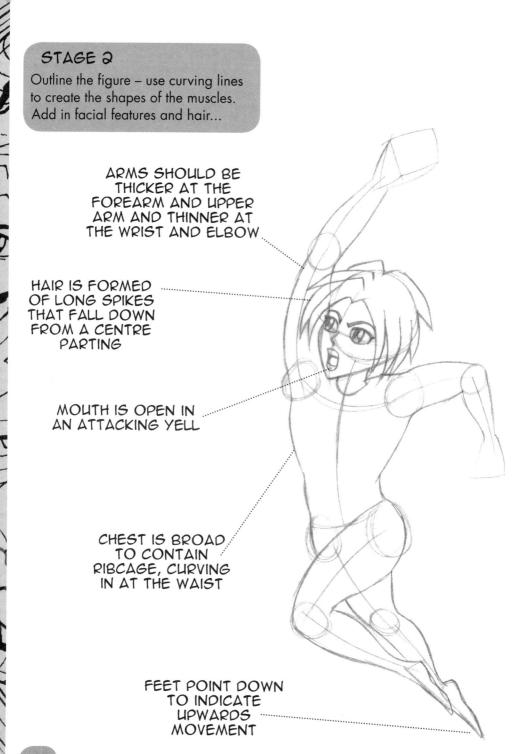

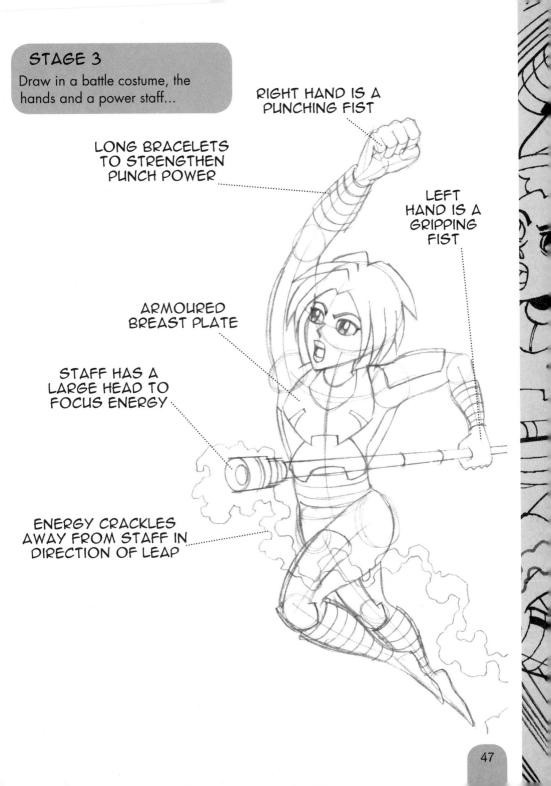

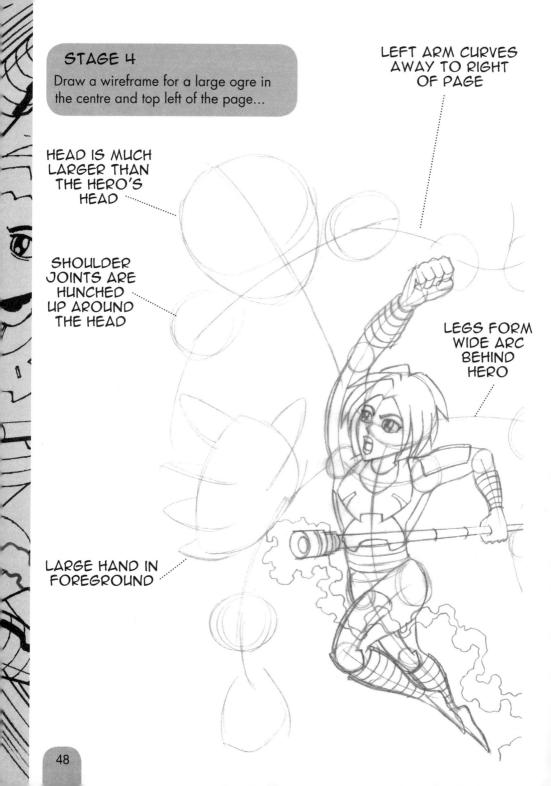

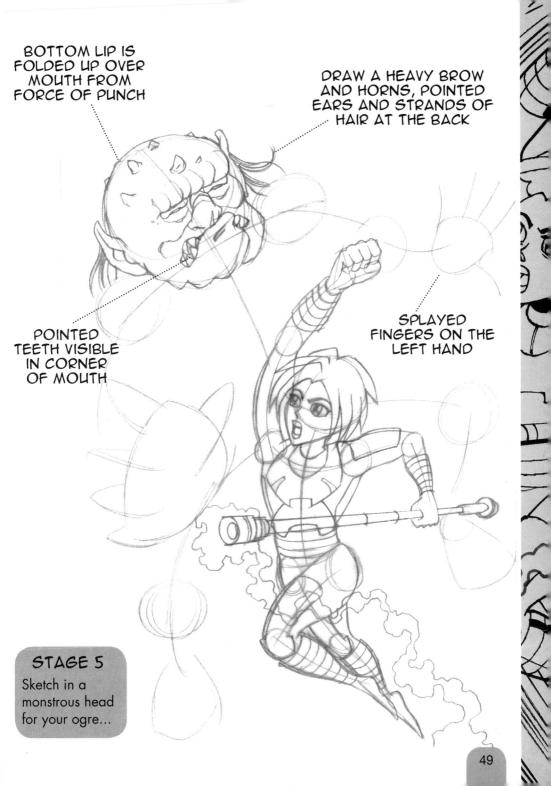

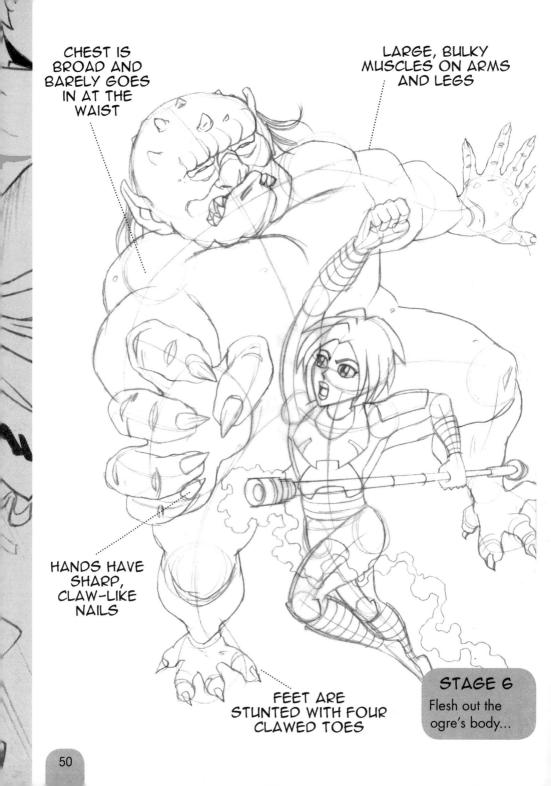

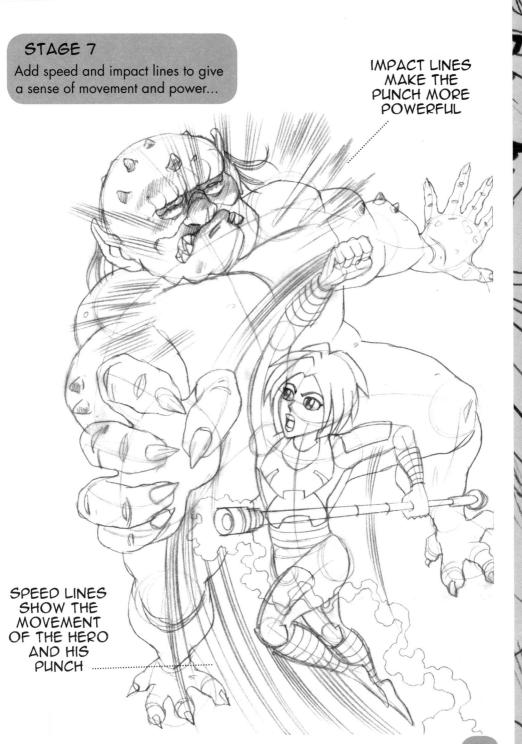

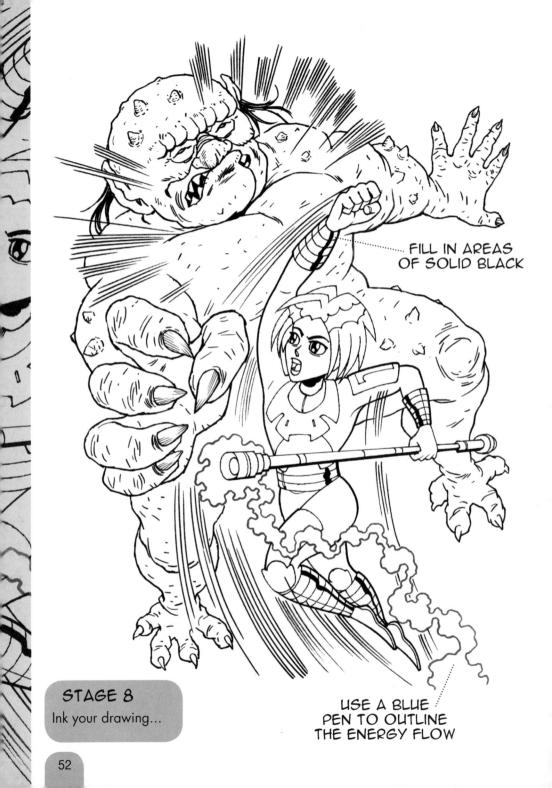

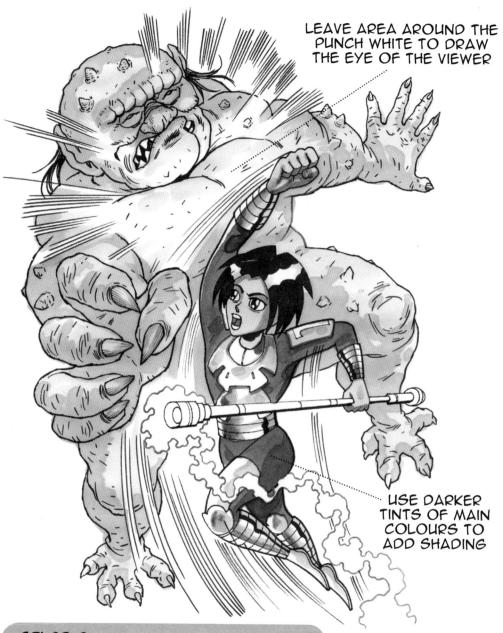

Colour your hero with blue, grey and flesh-coloured markers, and colour your ogre with dull shades of beige and grey. Add shading using darker tones...

EAVE WHITE AREAS AS HIGHLIGHTS STAGE 10 Colour the power staff bright gold-yellow and the energy crackle pale blue. Add

and the energy crackle pale blue. Add some faint colour to your speed lines..

USE PALE BLUE TO REFLECT THE COLOUR OF THE HERO'S COSTUME

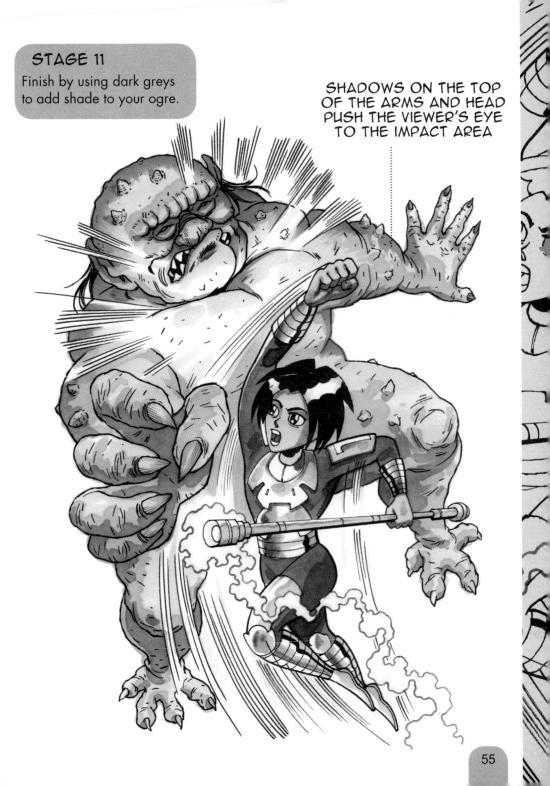

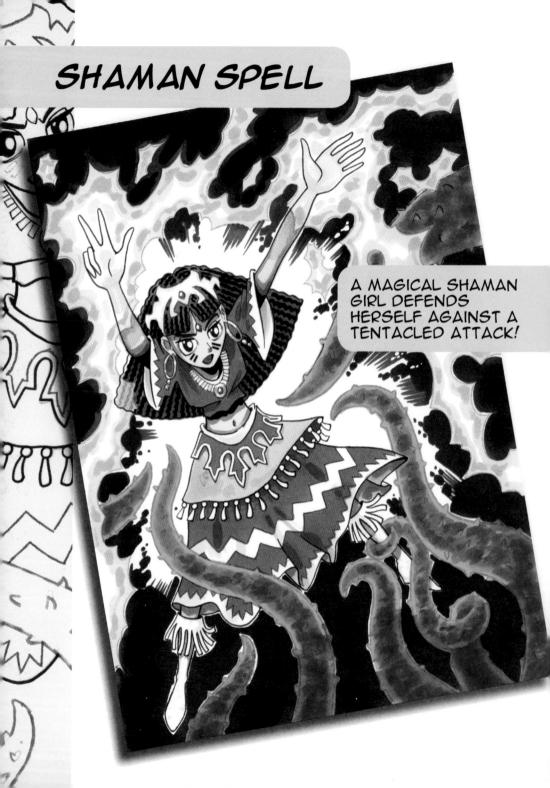

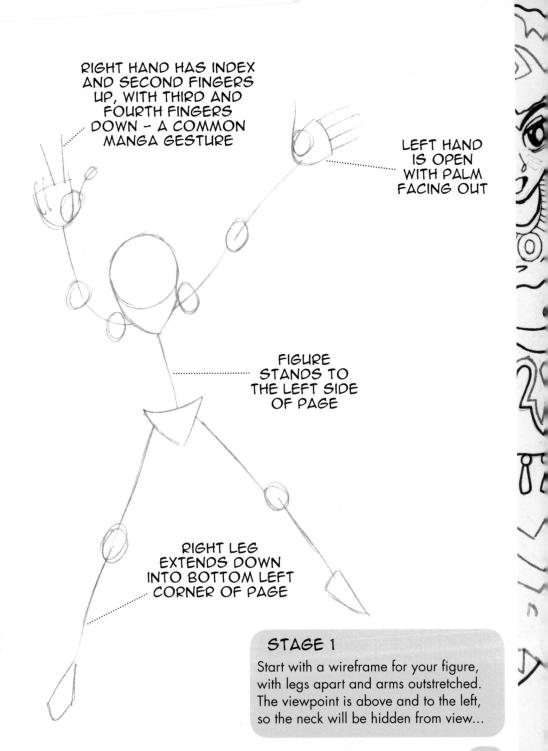

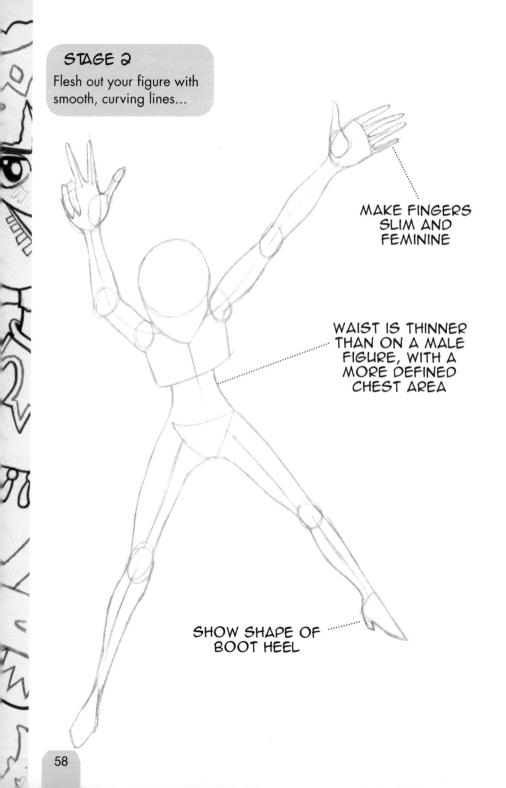

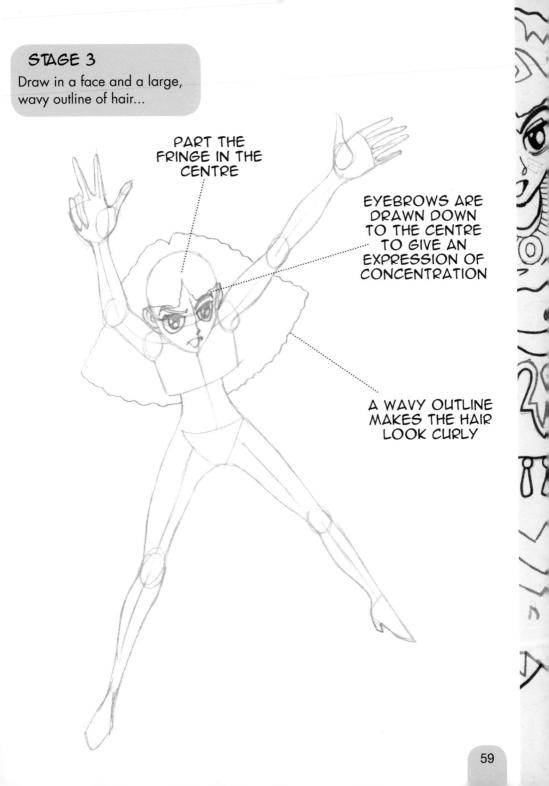

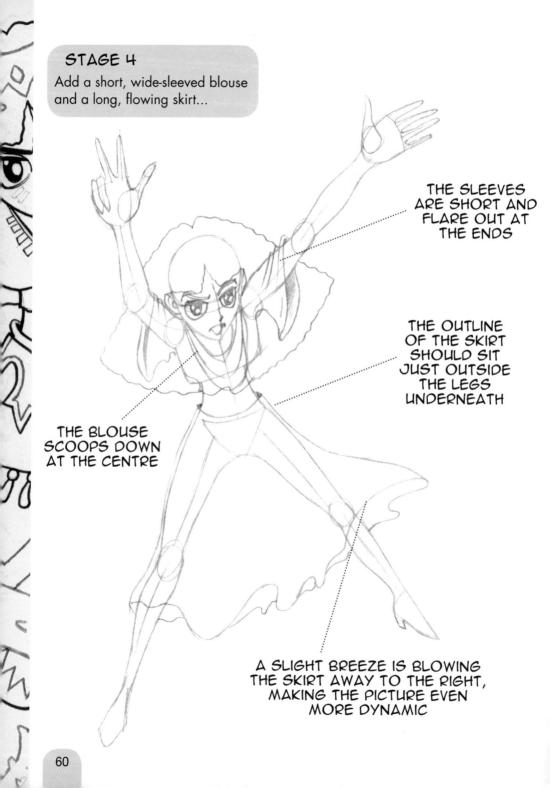

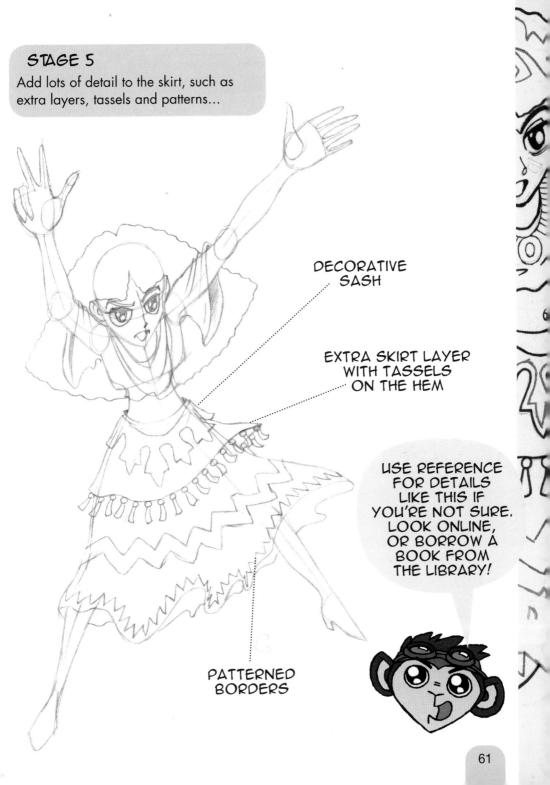

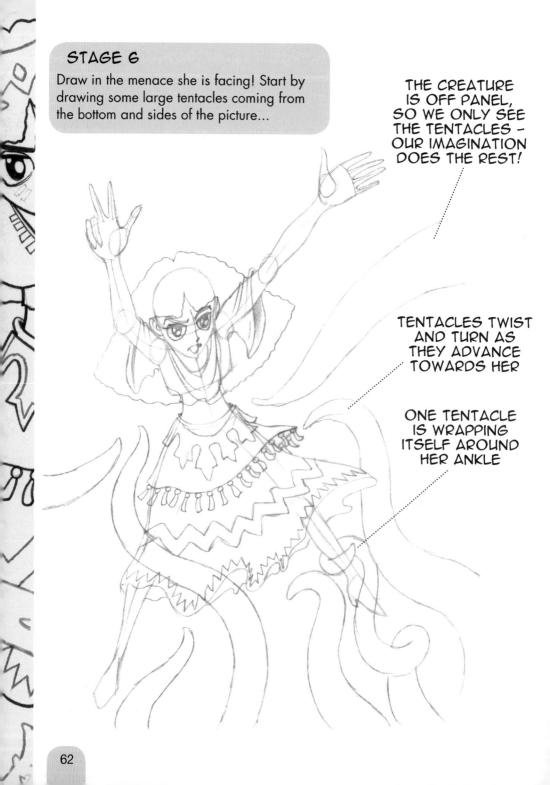

Add lots of crackling energy flowing from her hands and filling the surrounding air...

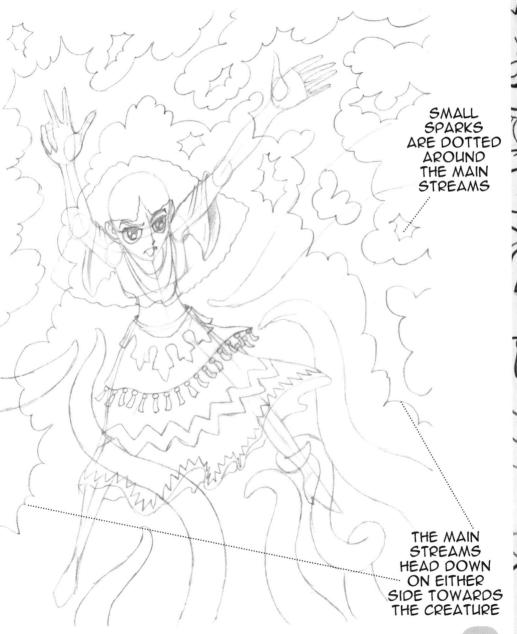

HEADPIECE, EARRINGS AND NECKLACE

Draw in some spiky details on the tentacles, and add some face markings and jewellery to the character...

2

91/1

ADD SOME TASSELLED BOOTS

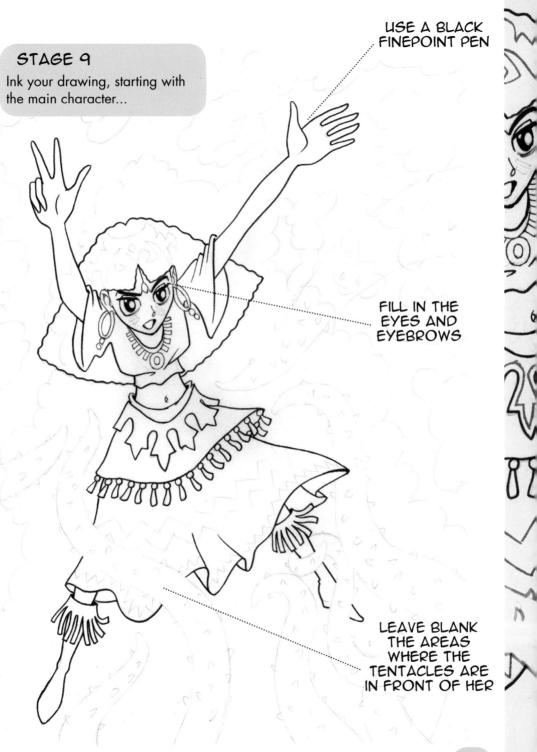

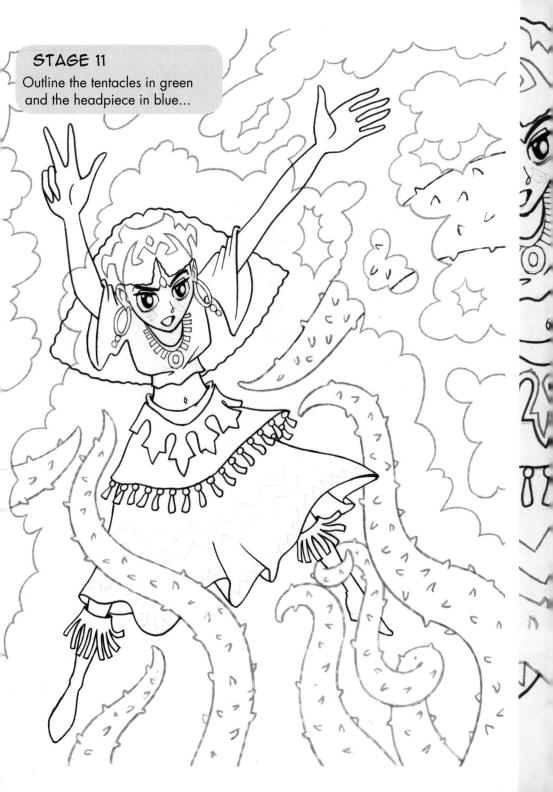

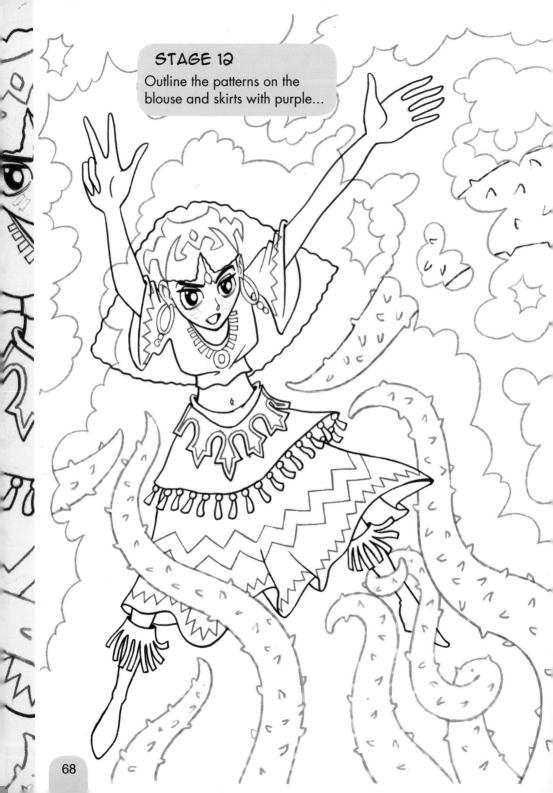

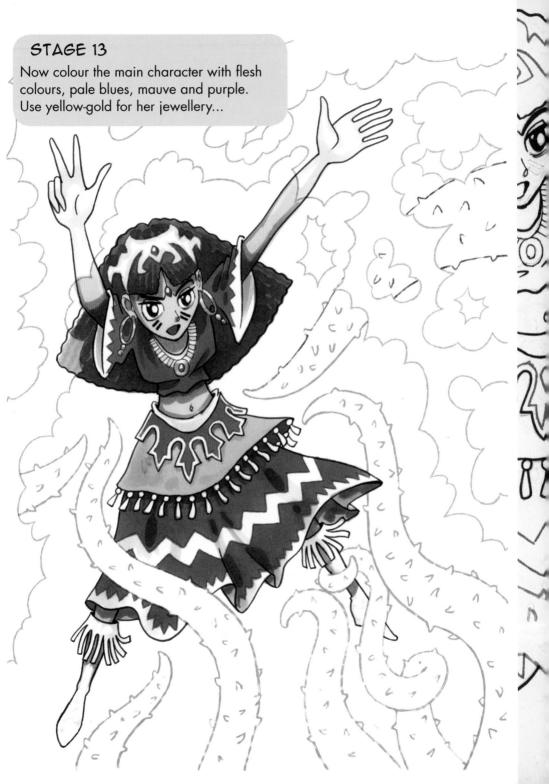

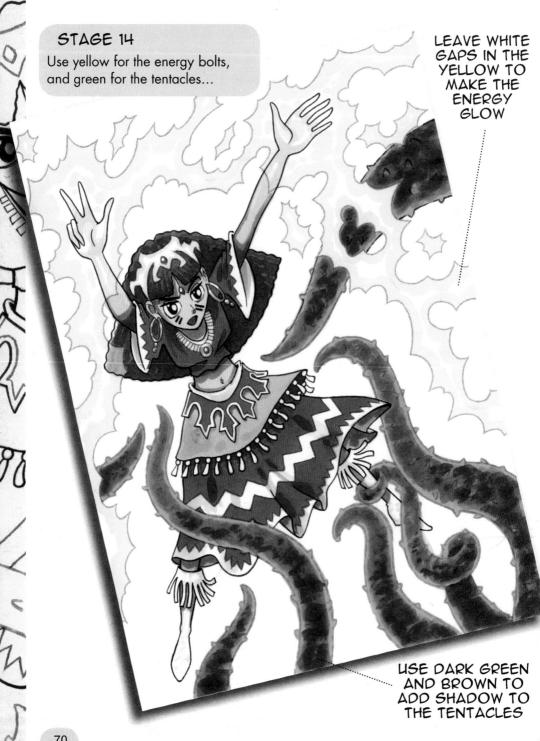

.8

NN

Add some black shadows on the figure and wavy lines to the hair. Finish by filling in the background with a dark, rich brown colour, leaving a white centre behind the character.

THE

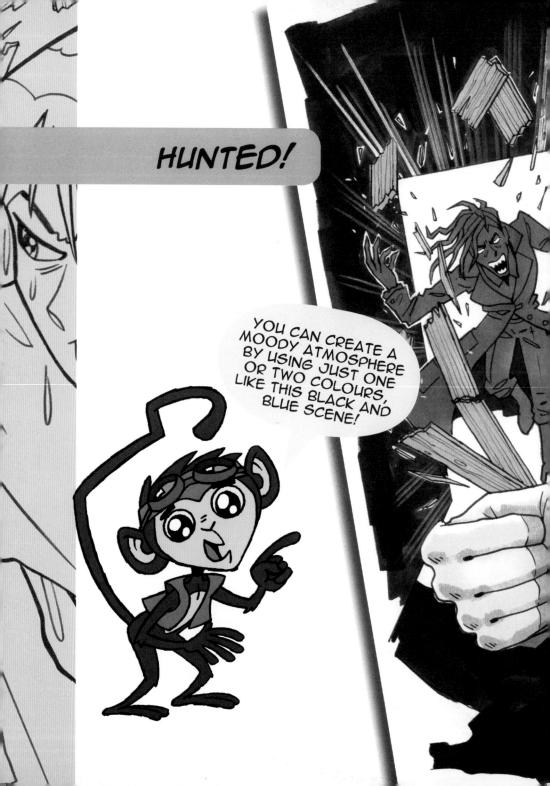

ピイ

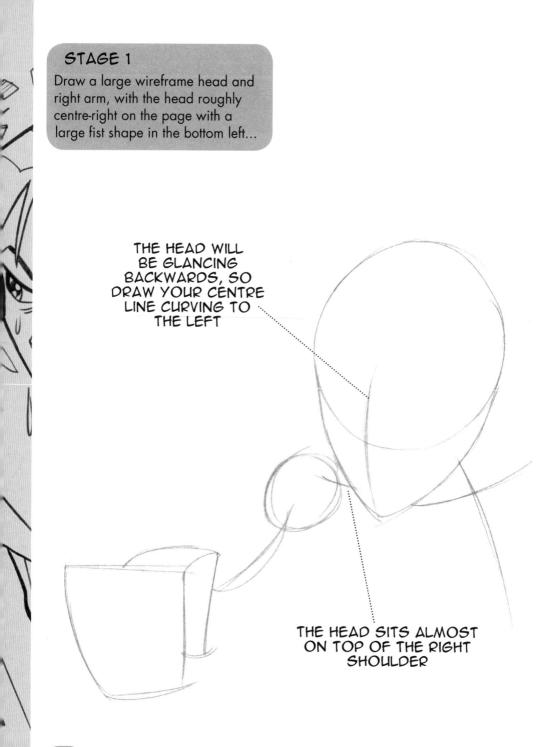

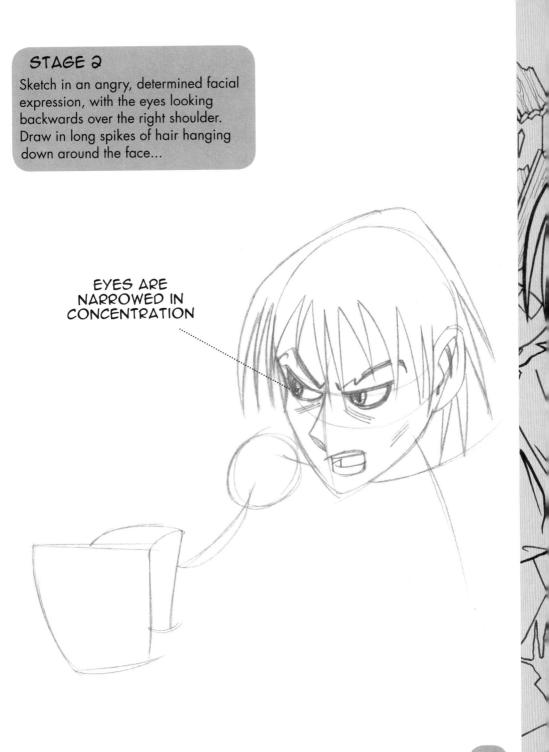

Flesh out the figure, creating a shirt with a tattered, jagged outline to show that the character is in distress. Draw in the clenched right fist. Add some sweat drops on the face and dripping down towards the floor...

In the background draw a rectangle for a door and sketch a wireframe for a second figure entering through it. The second figure's head is down and forwards, hiding the neck; its right leg is bent at the knee and it has longer than usual fingers...

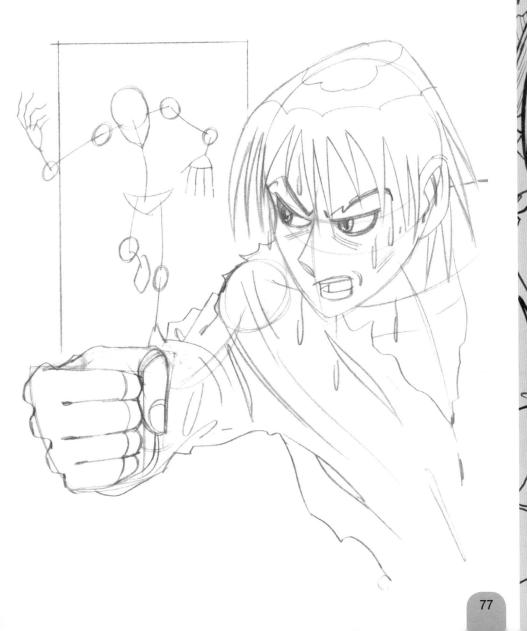

Flesh out the second figure, giving it a trenchcoat, boots, long messy hair and spindly hands. Indicate sharp teeth and evil-looking eyes...

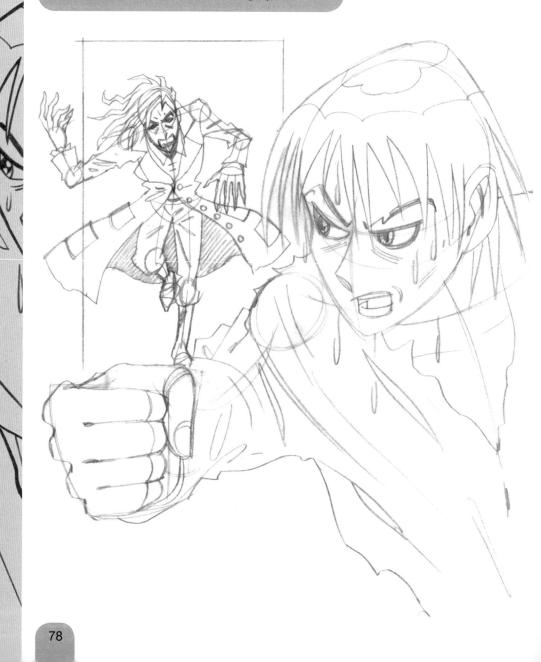

CREATE LOTS OF

SMALL SPLINTERS AND FRAGMENTS

OF WOODEN

PLANKS

Sketch in the splintered remains of the door the second figure is crashing through. The light source will be outside the door, so indicate the shadow he's casting at the bottom of the page...

STAGE 7 Ink your drawing with black pen, using a thicker pen or brush pen on the foreground character to make him more dominant in the picture... Ó 1

1

1

1

Д

Colour the foreground character: use pale blue on the face and hand, and mid-blue on the shirt. Leave a white highlight around the edge to show where the light is hitting him...

1

Colour the hair black with a pale blue highlight, and add mid-grey shadows on the face and hands. Use a darker grey to put shadows on the shirt...

1

1

۵

Colour the second figure with dark blue, leaving the eyes and teeth white. Fill in the mouth and the inside of the coat black...

11

0

Colour the background and the shadow on the floor black – the colour doesn't have to be neatly applied. Colour the splintered remains of the door with mid-grey...

Use dark grey to add some final shadows and to draw in some texture lines on the hero's hair. Finish with some white paint: add impact lines coming out from the door, movement lines on the hero's body, and add a few more small splinters!

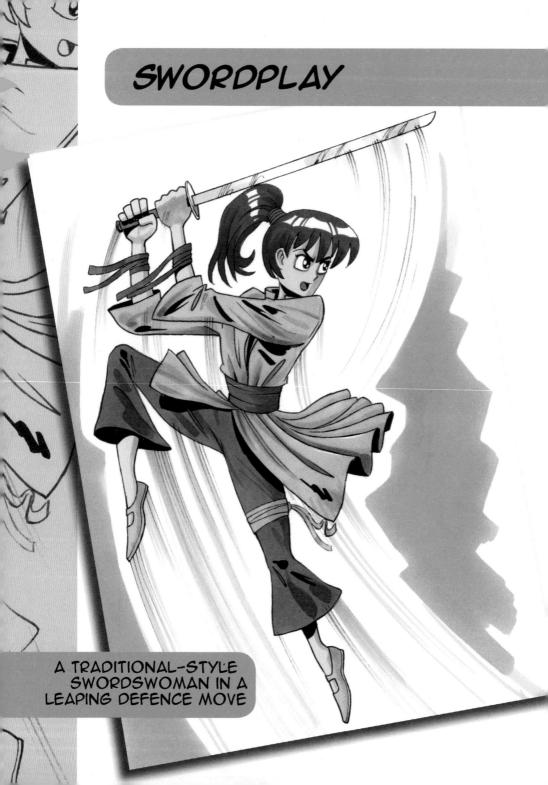

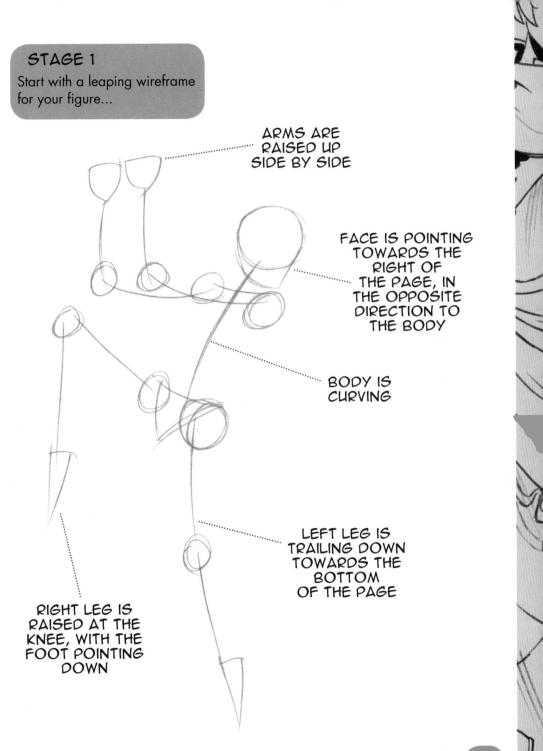

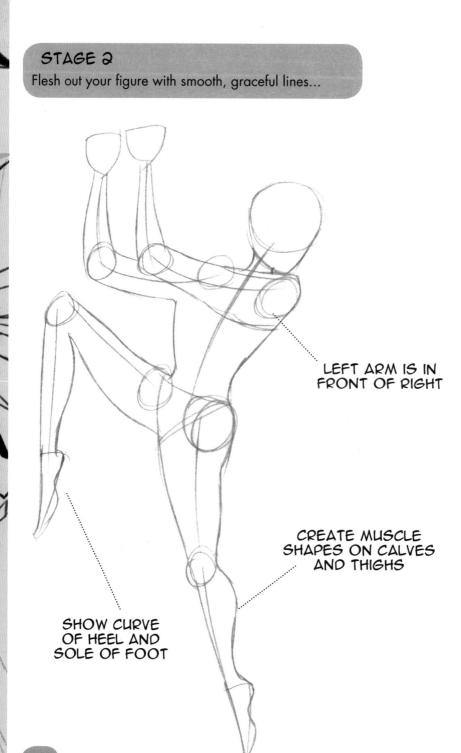

Draw in her face, long hair in a pony tail, and hands gripping a long sword...

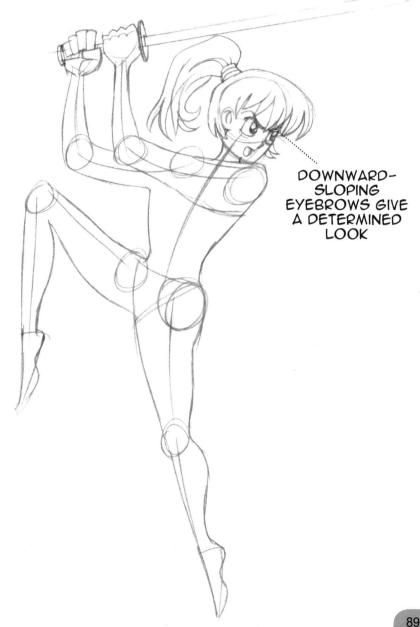

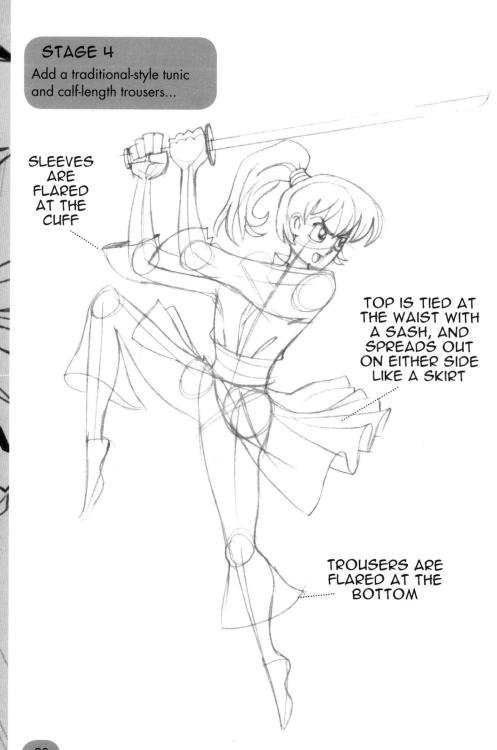

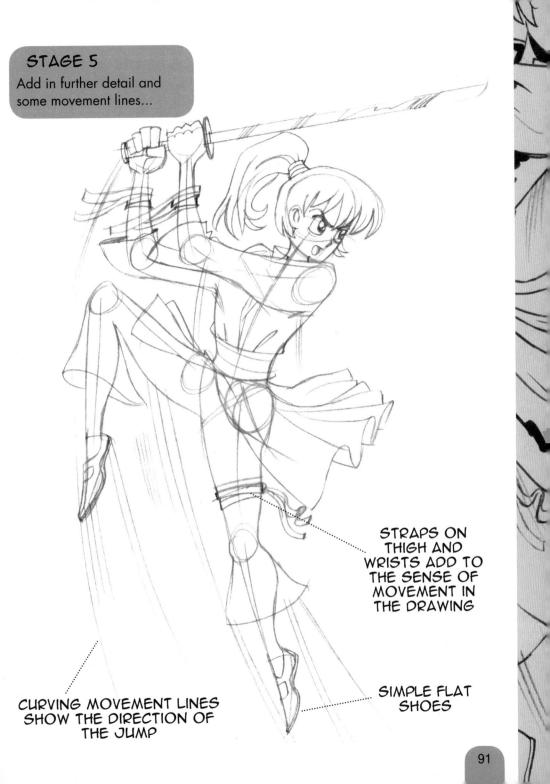

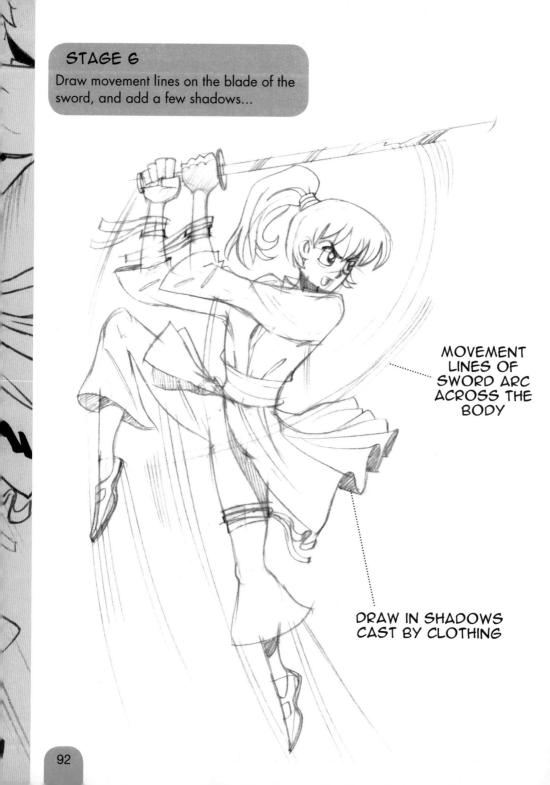

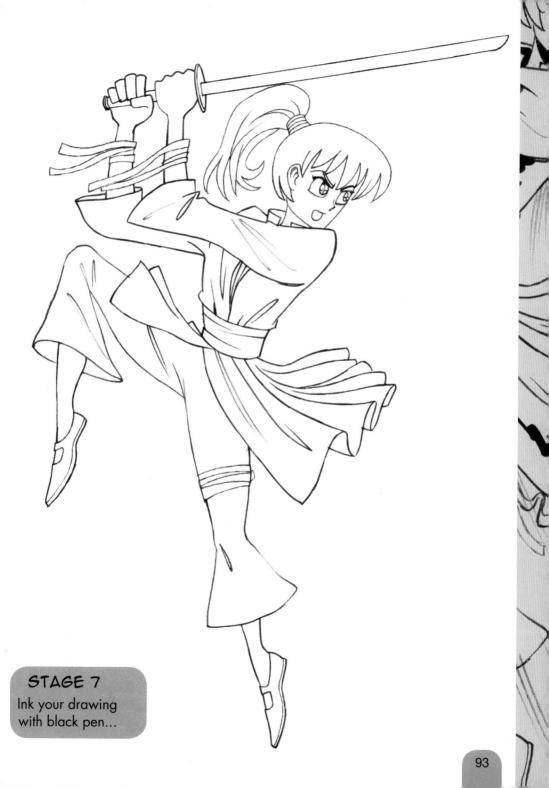

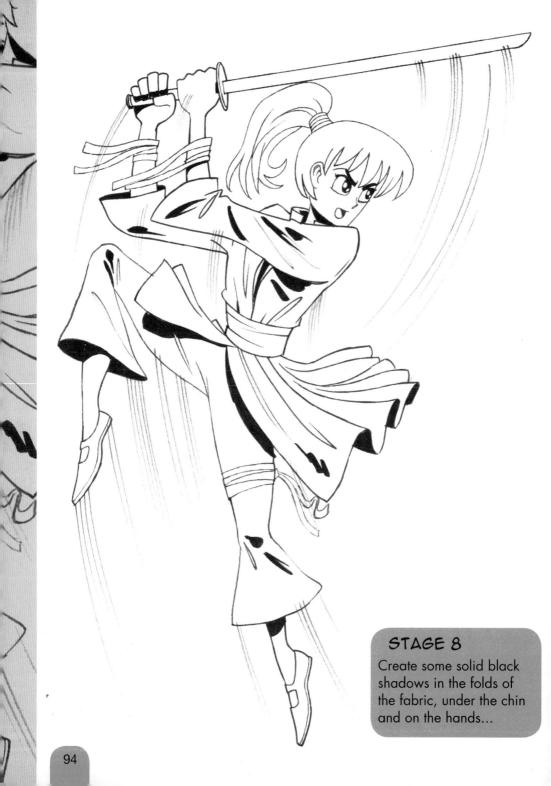

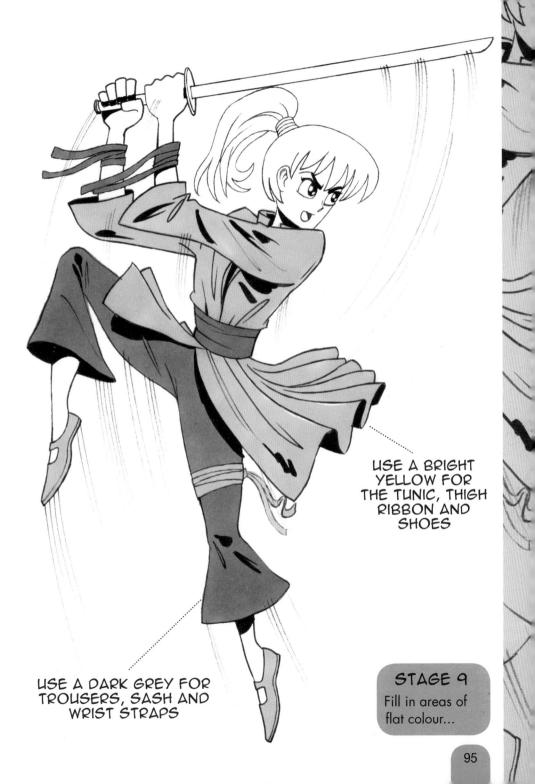

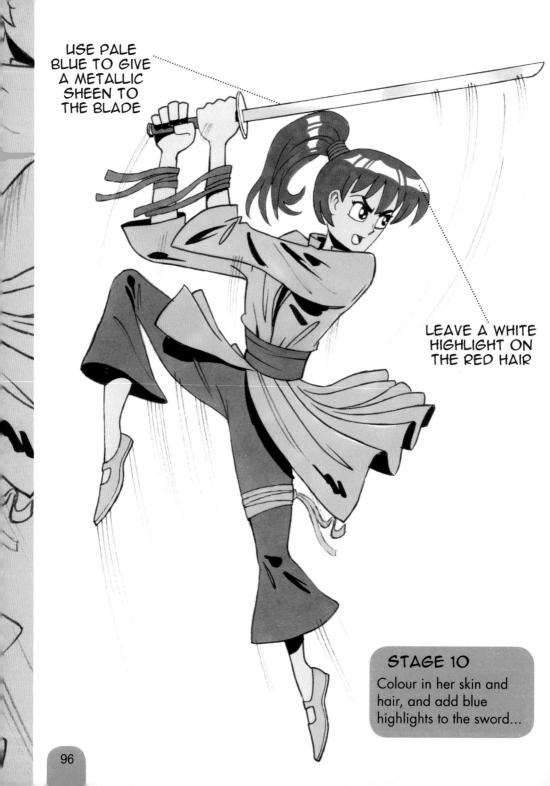

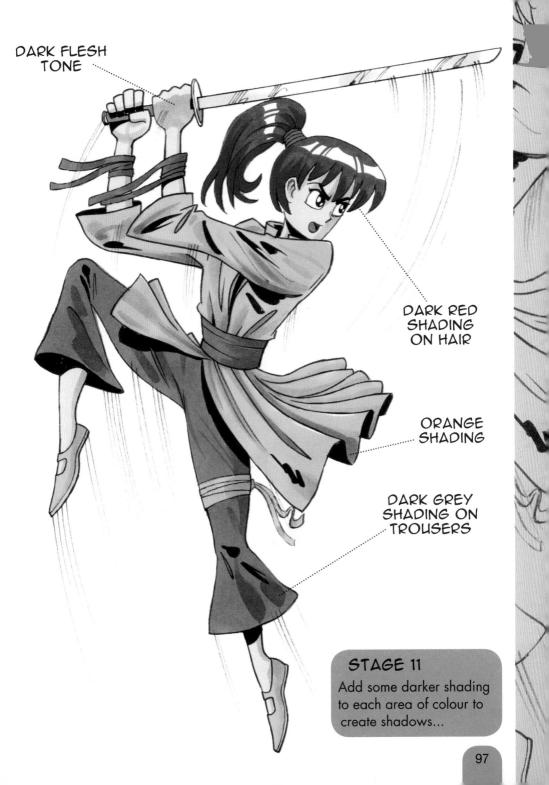

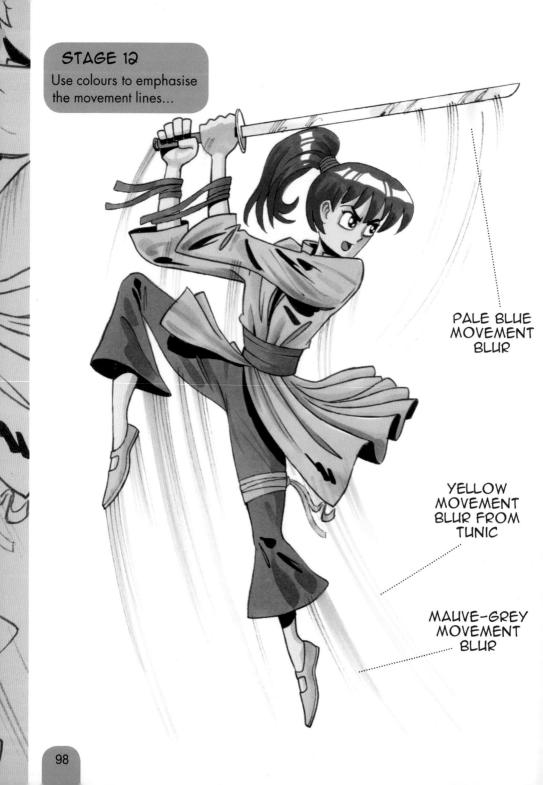

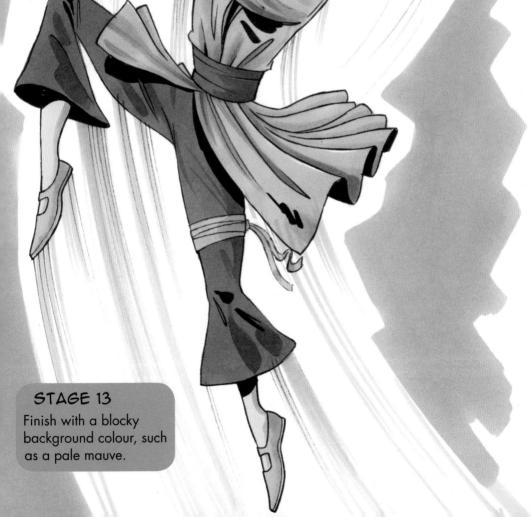

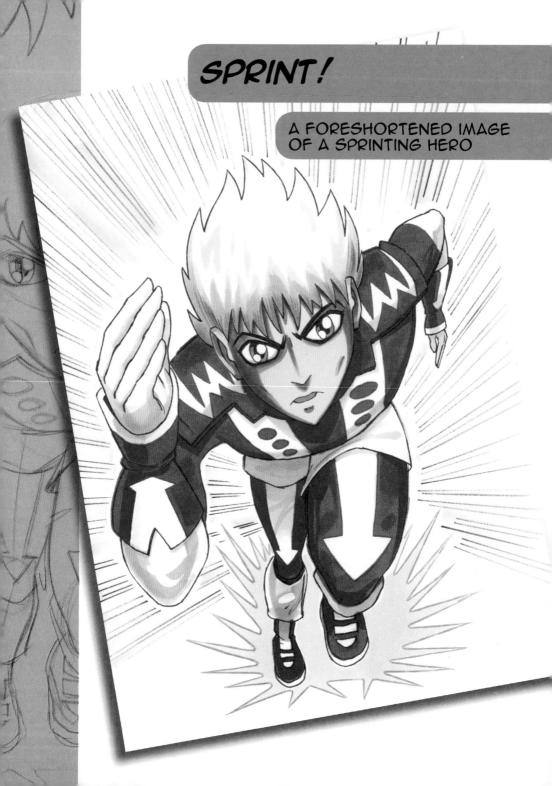

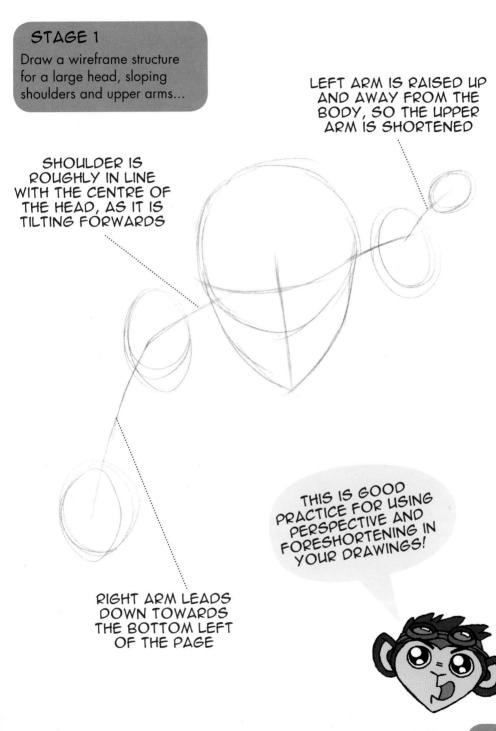

Draw in a large wireframe forearm and hand on the figure's right side, and a small forearm and hand on the left. Sketch in the upper torso...

FINGERS ARE CLOSED AND ANGLED INWARDS

CHEST AREA SITS UNDERNEATH THE HEAD, WHICH IS TILTED FORWARDS

RIGHT ARM IS RAISED AT THE ELBOW

Draw in wireframe legs. The perspective means that the legs will appear much smaller than the top part of the body...

> THE LEFT LEG IS THE LEADING LEG, SO IT'S BENT FORWARDS AT THE KNEE. THE VIEWER WILL ONLY SEE THE THIGH AND PART OF THE FOOT

THE RIGHT LEG IS THE TRAILING LEG, SO IT LOOKS MUCH SMALLER THAN THE REST OF THE FIGURE

Flesh out your figure with curving lines as shown. Note how large the character's right forearm is in comparison to the left...

> SEE HOW THE OPPOSITE ARM AND LEG ARE FORWARD IN THE SPRINT: THE RIGHT ARM AND LEFT LEG ARE IN FRONT, THE LEFT ARM AND RIGHT LEG ARE BEHIND

Draw in a determined face with a sharp, pointed chin and spiky hair...

THE CHIN IS POINTED TO EMPHASISE THE FORWARD MOVEMENT

THE HAIR STYLE RESEMBLES A FLAME, WHICH CAN SUGGEST HEAT AND SPEED TO THE VIEWER

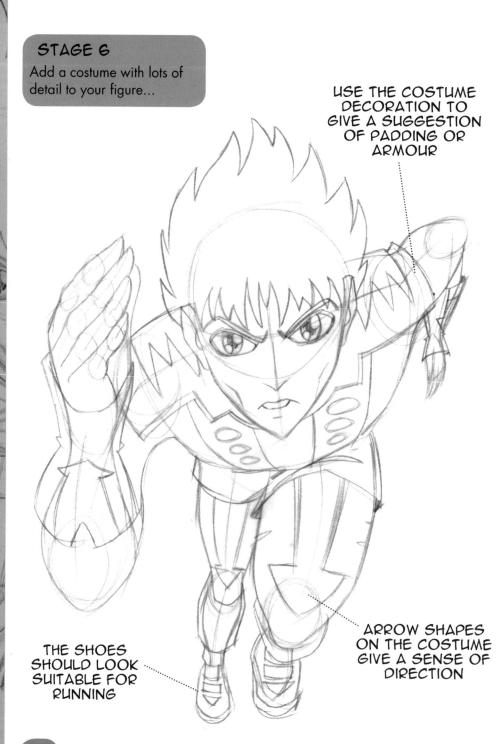

Draw a flash shape around the feet, and add in speed lines. The speed lines should all come from the centre of the page and radiate out towards the edge...

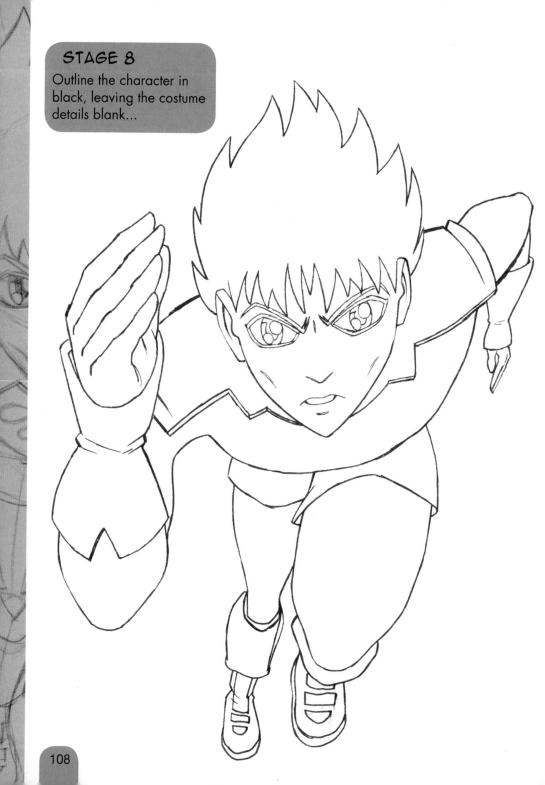

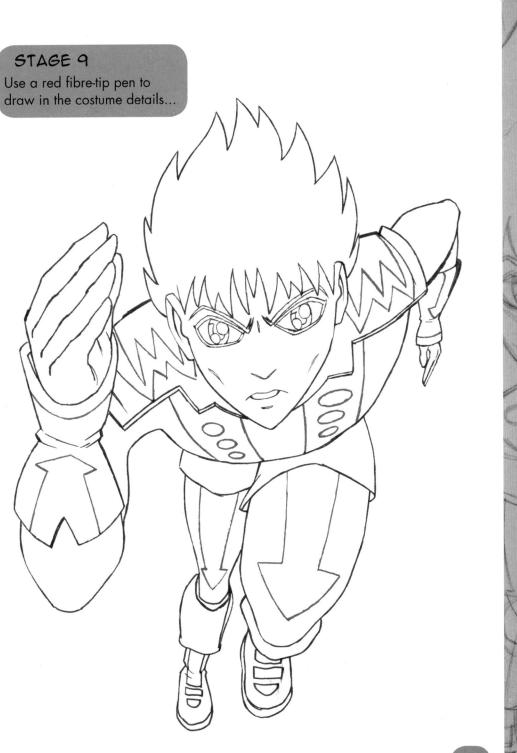

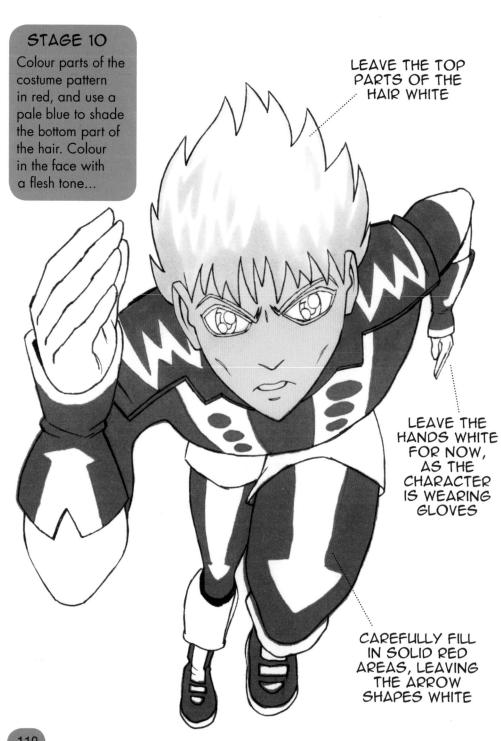

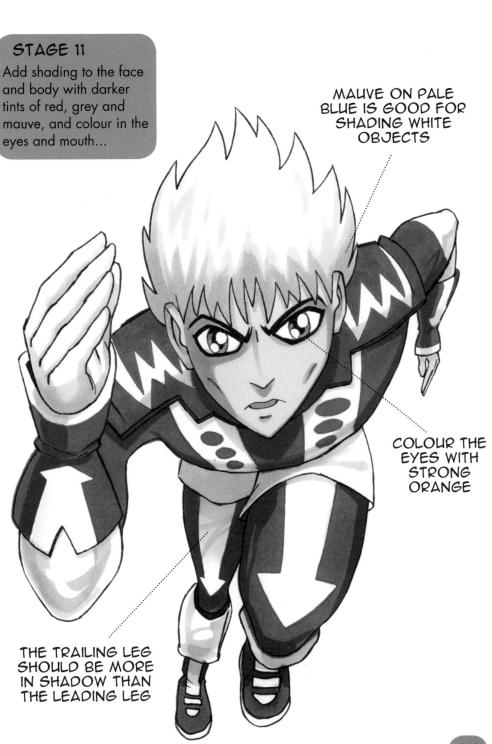

Use a dark grey or black finepoint pen to draw in the speed lines with a ruler, and outline the flash in yellow...

Finish with some pale blue marker to add depth to the speed lines, and fill in the flash with bright yellow. Add some more shadow to the face and body.

111

JUMPING ATTACK!

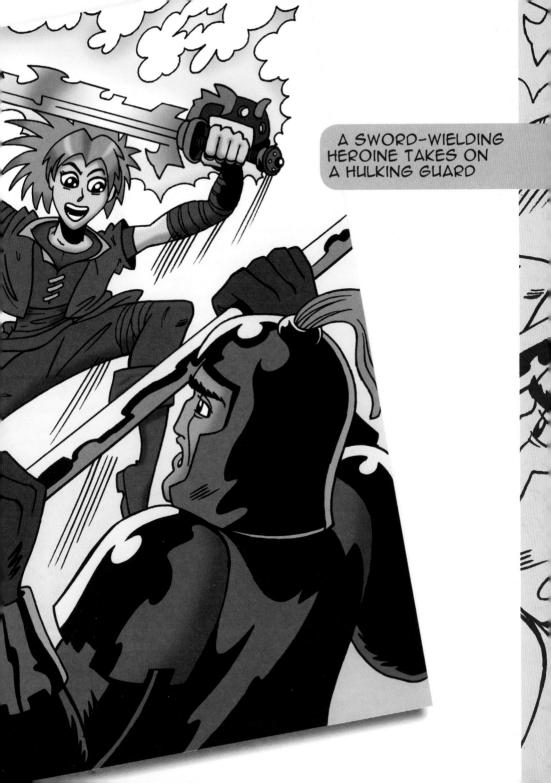

LEFT ARM WIELDS A SWORD OVER THE HEAD

THE RIGHT ARM IS STRETCHED BACK WITH THE FINGERS SPREAD

> THE LEFT LEG IS LEADING THE JUMP, SO IT'S RAISED UP AND BENT AT THE KNEE

STAGE 1 Create a wireframe guide for a leaping figure in the top half of the page...

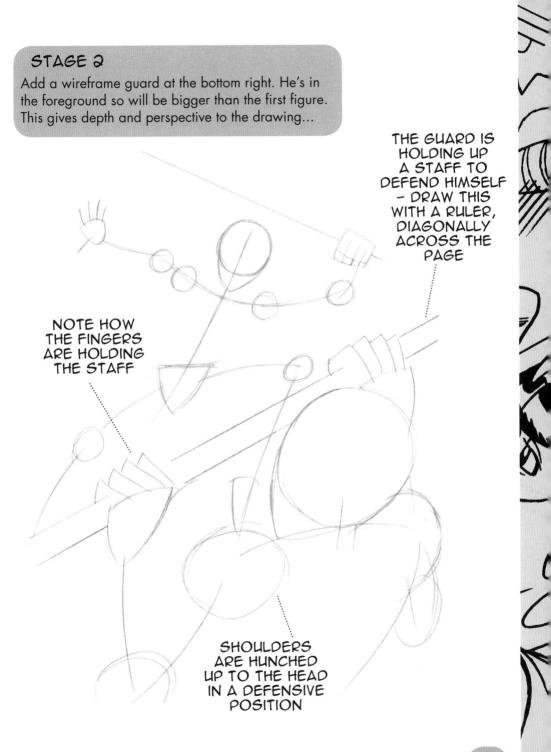

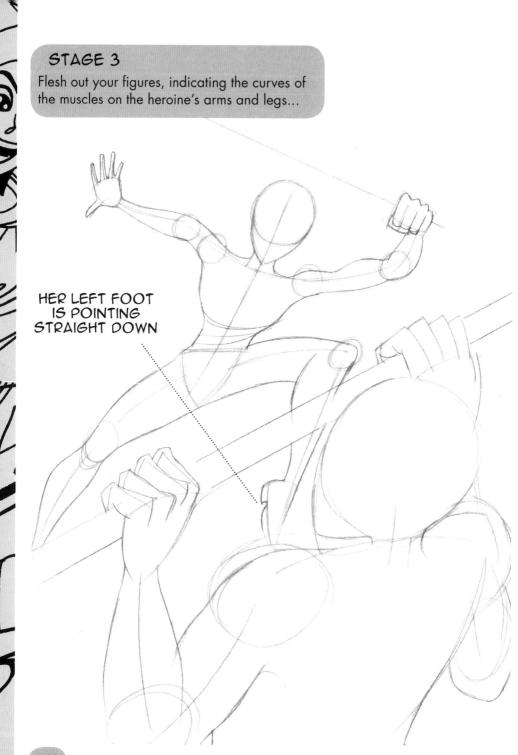

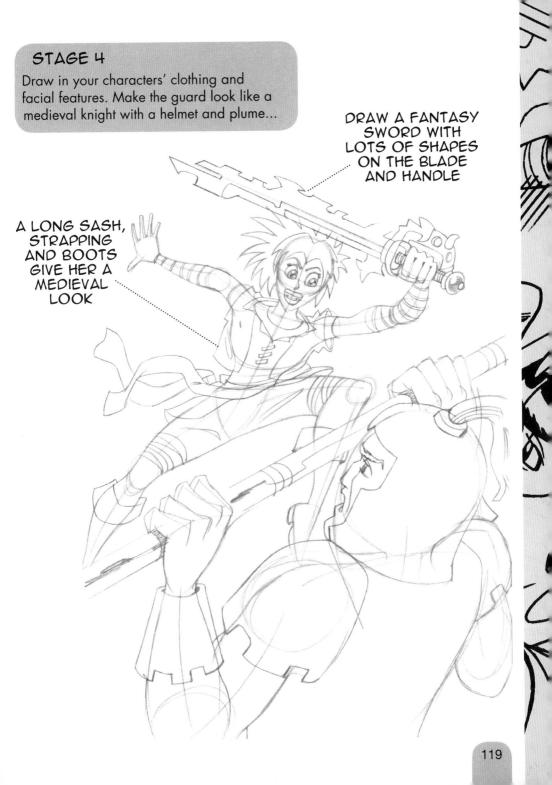

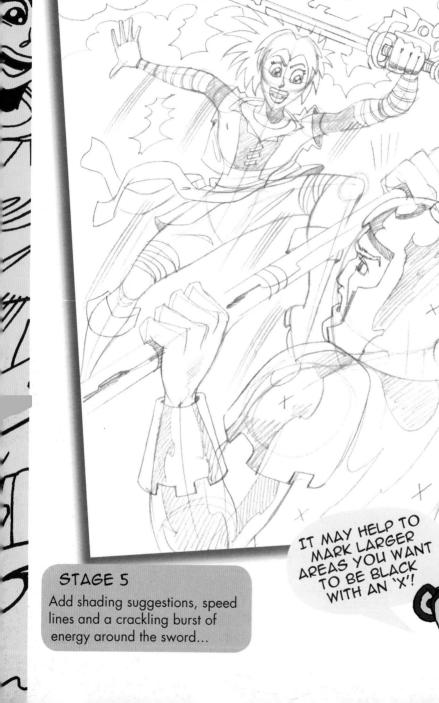

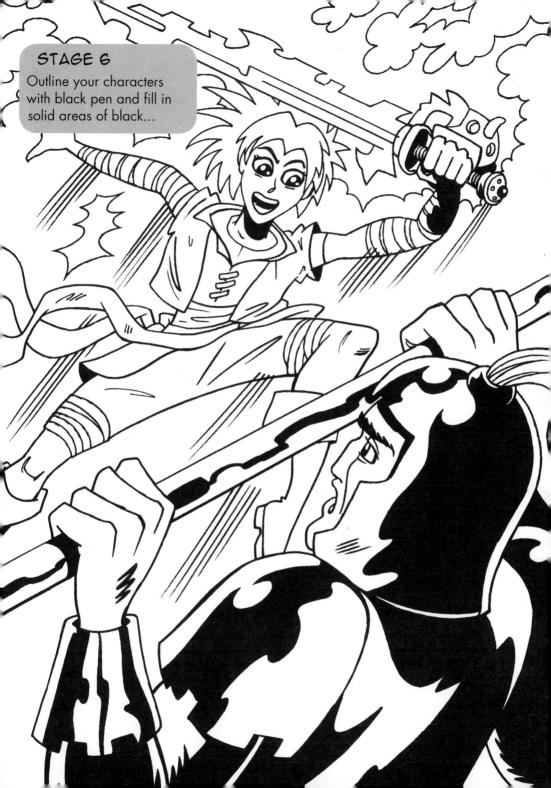

If you are using a computer, scan your linework and make the contrast 100 per cent, then add colour (see page17). Use a darker colour for the guard to draw the eye to the heroine. If you don't wish to use a computer, colour using markers instead...

Finish by adding some shading, using darker tones, and some white highlights, such as those on the heroine's hair. These final touches are really important: computer programmes can give a very 'polished' look, but can make the drawing a little flat.

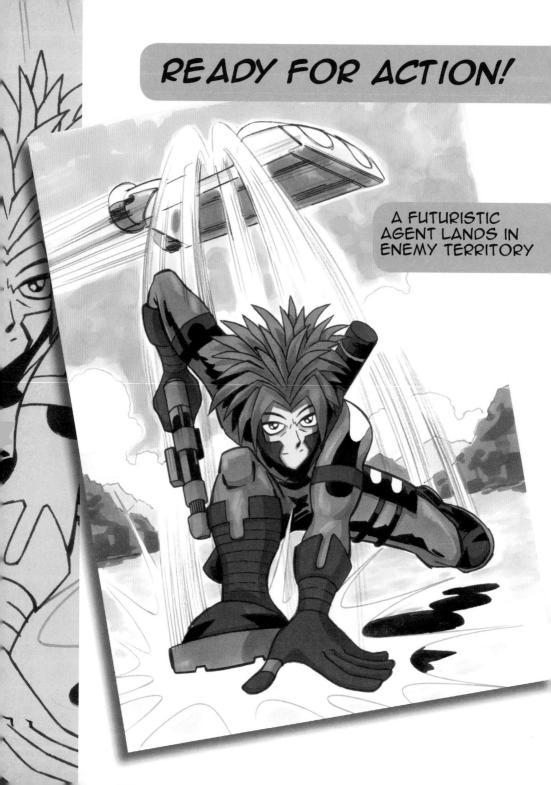

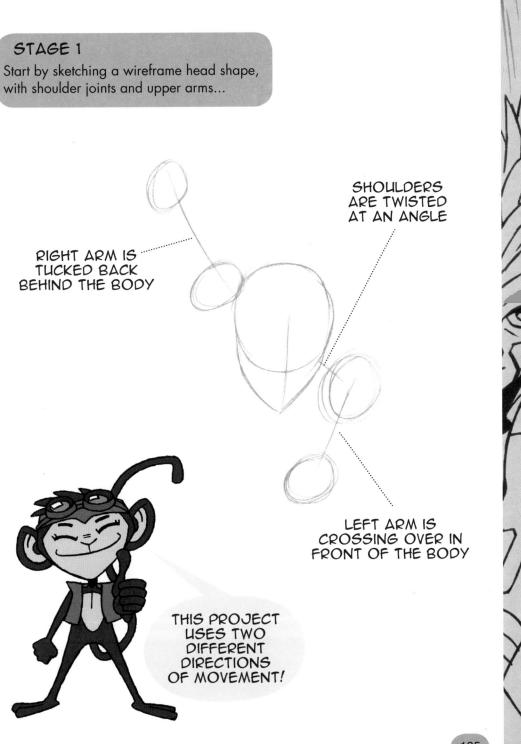

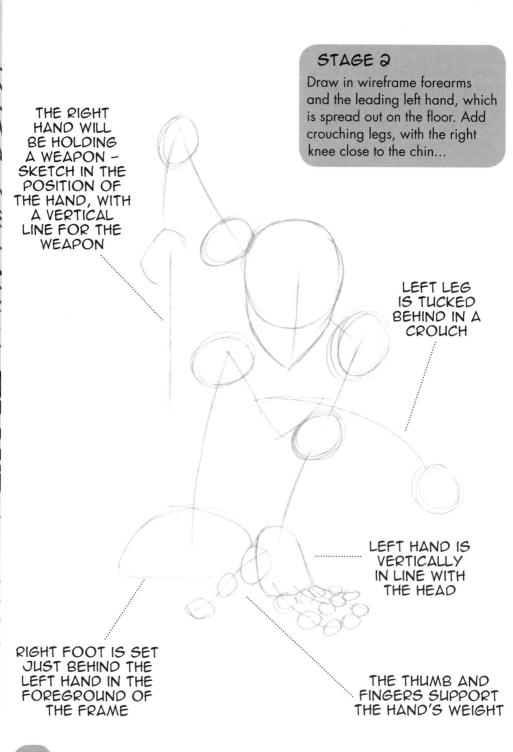

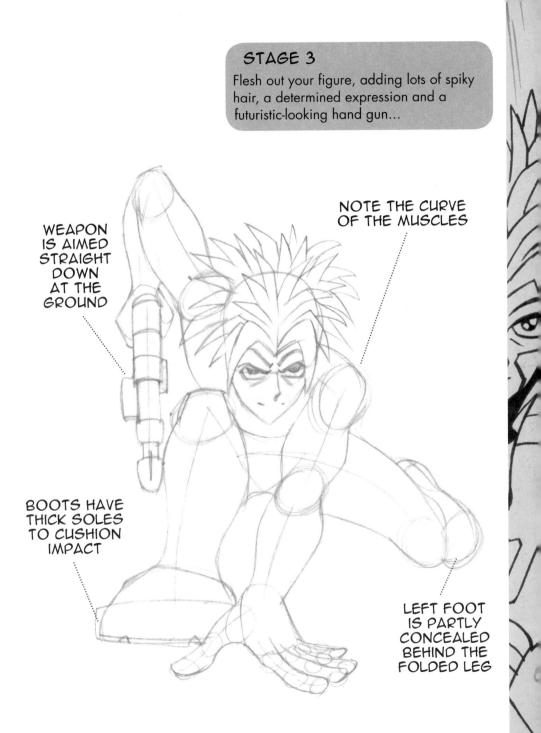

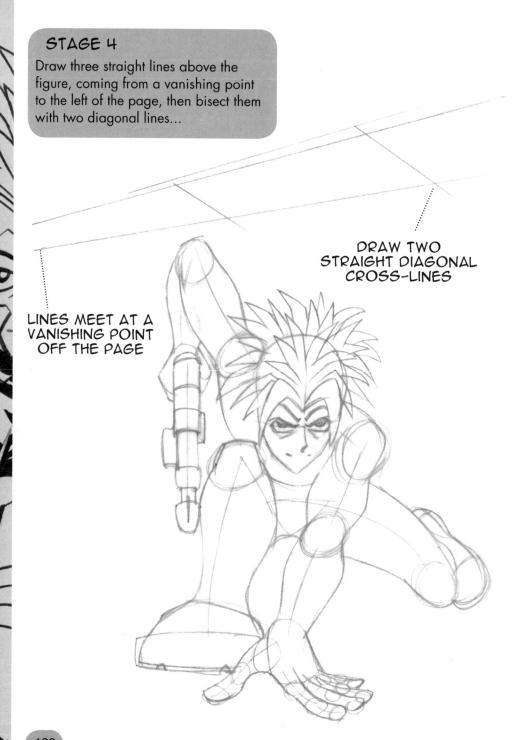

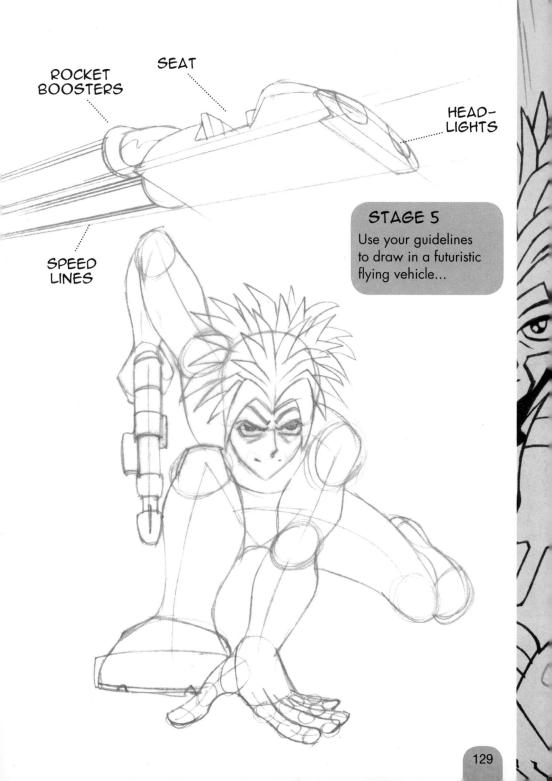

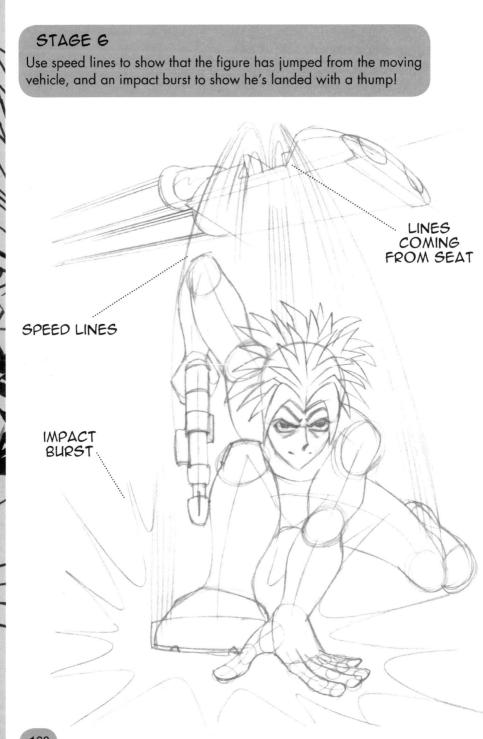

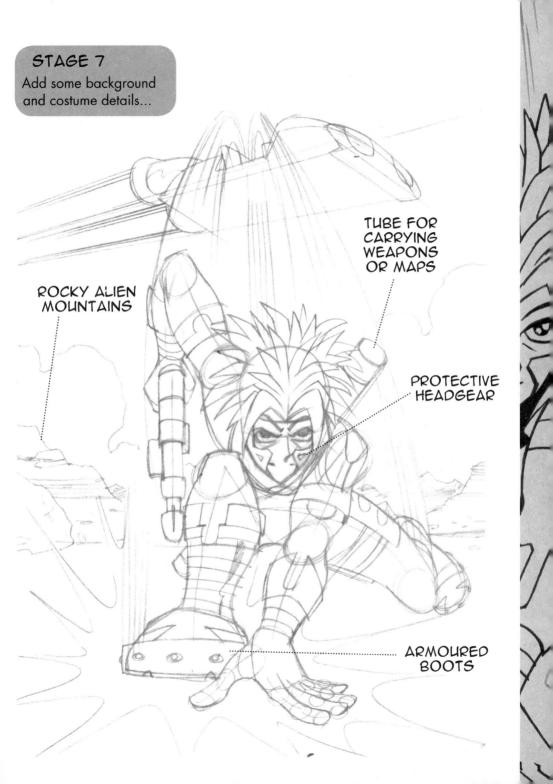

Outline your figure in black. I've used a combination of black fine pen and brush pen here to give a variety to the line weight...

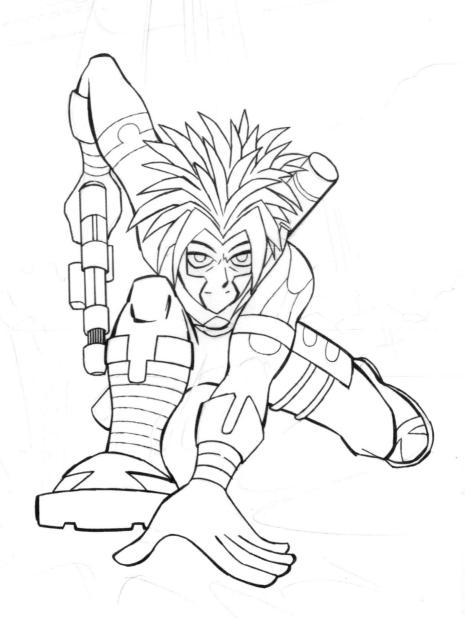

Outline the rest of the drawing in a mid-grey or brown pen to make the figure stand out...

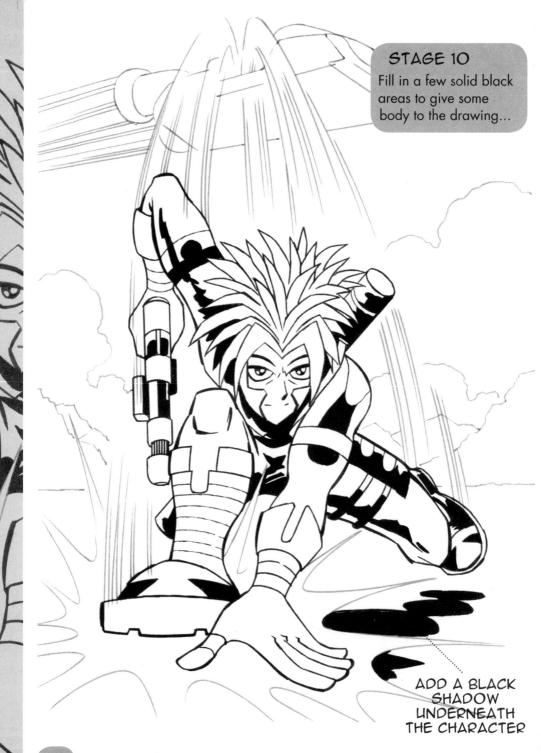

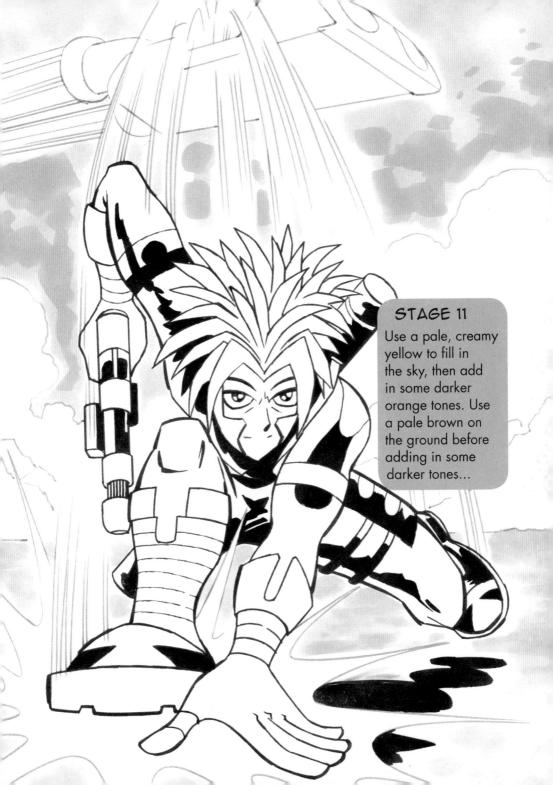

Use a mid-grey for the mountains, with a paler grey for the ones further back. Add some pale cream to the base of the clouds, leaving the upper parts white...

STAGE 13 Colour your character's costume, hair and face...

Add some blue, grey and mauve to the vehicle, and use darker tones to shade the background and figure...

Add colour to the speed lines and finish by putting in some more dark and light tones to make your drawing really dynamic!

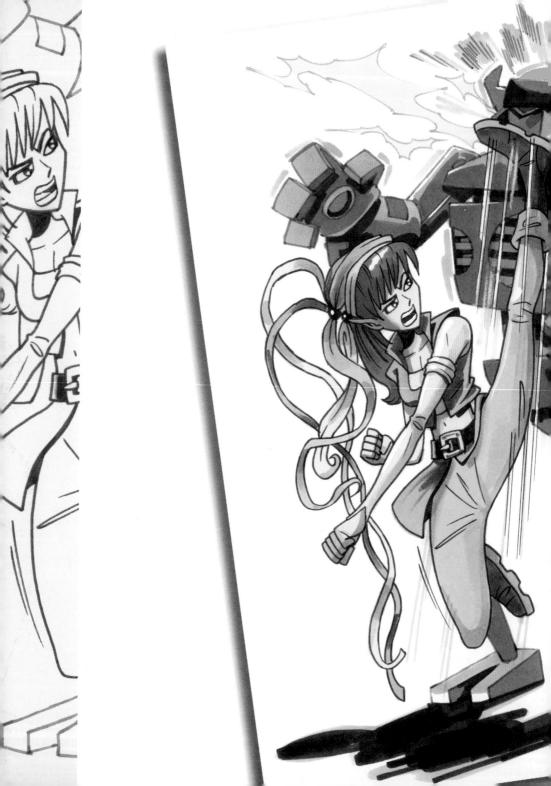

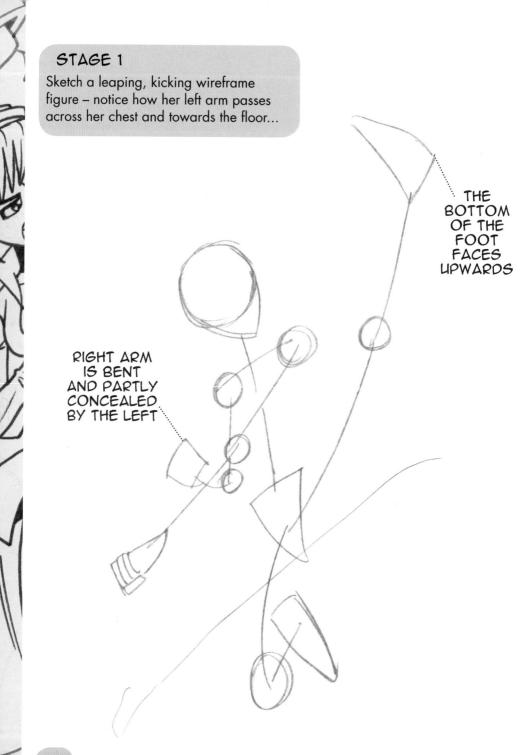

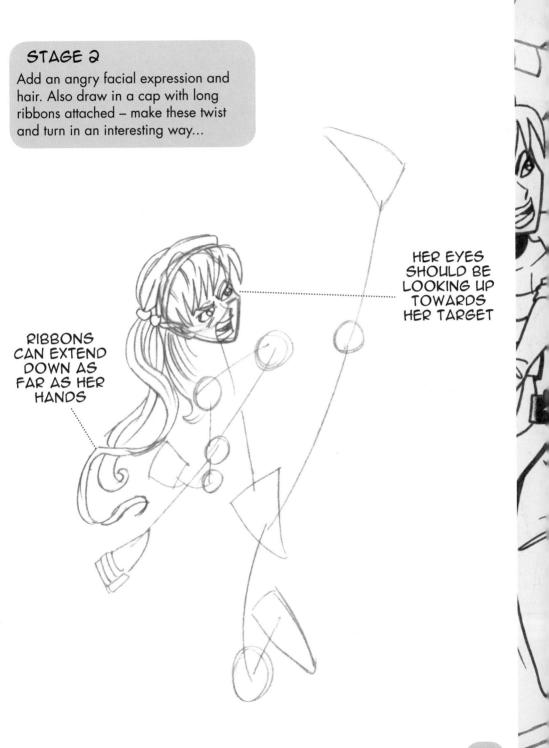

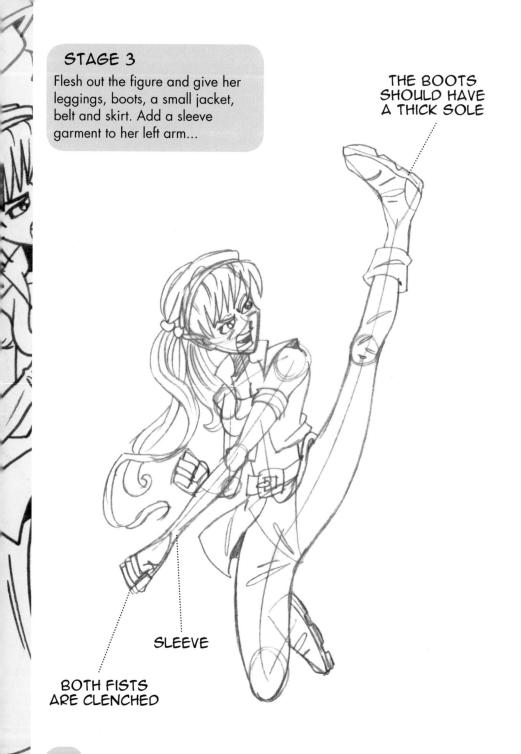

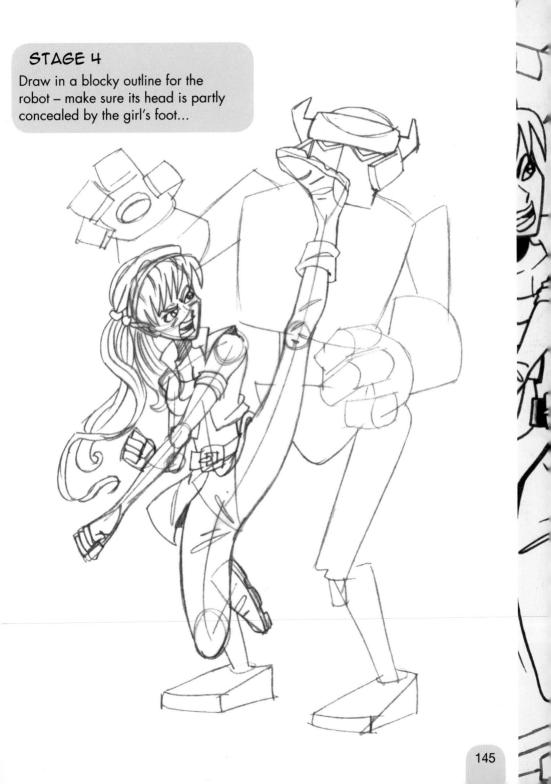

Add some extra ribbons to the girl's cap and draw speed lines for her legs. Add impact lines and electricity bursts coming from the robot's head and fill in more detail on its bodywork...

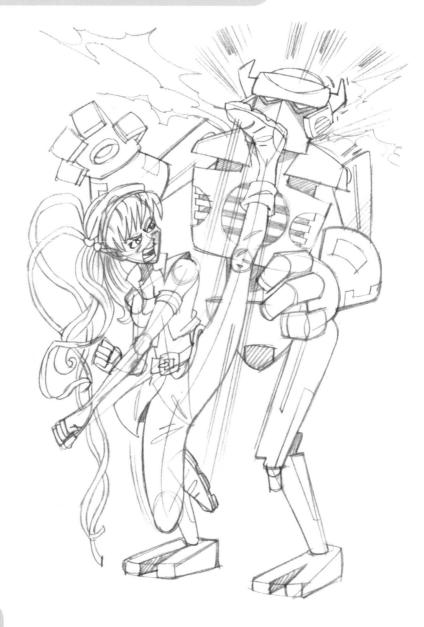

Outline the girl in black and the robot in grey. Use a red pen to outline the electricity bursts...

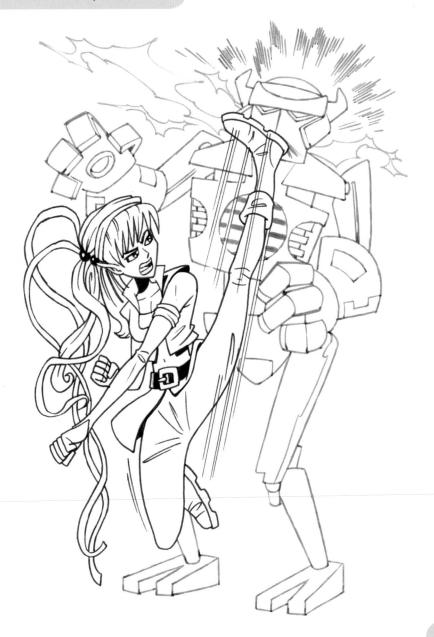

Colour the girl's skin tone and hair. Fill in her clothes with greens and yellows, then shade with darker tones...

Colour the robot with mid-grey, adding some darker grey detailing, red eyes and an orange palm laser...

Work in some darker greys and black on the robot and add blue to the chest grill area. Colour the electricity bursts in yellow and use a pale grey to highlight the impact lines behind the robot's head...

Finish by adding some more movement lines to the girl's legs in green pencil and white paint, grey 'shudder' lines around the edges of the robot, and a dark grey-black shadow on the ground.

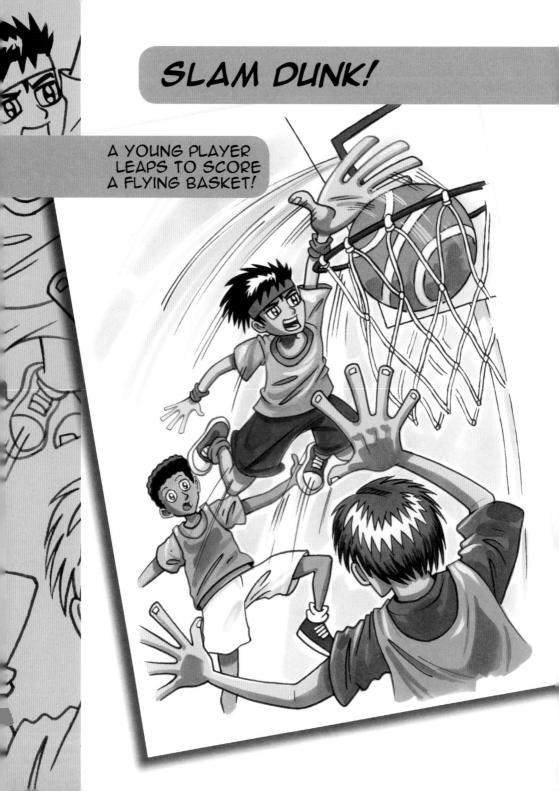

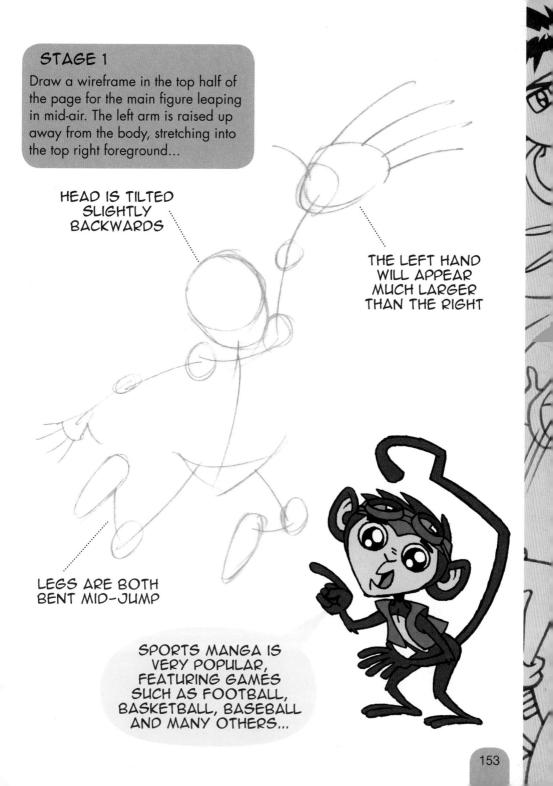

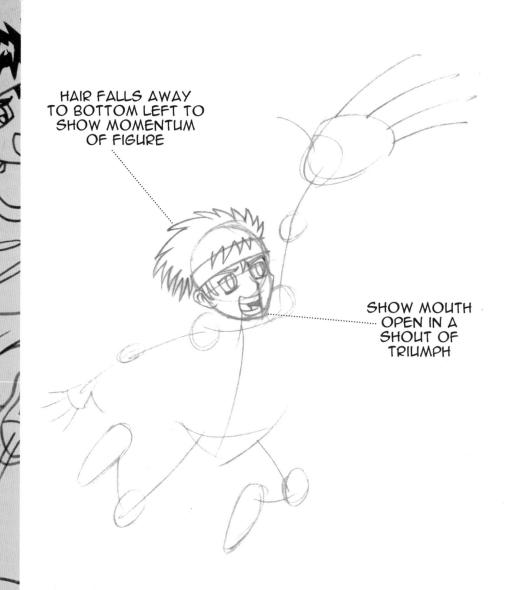

Sketch in a face with a determined expression. Add spiky hair and a sweatband across his forehead...

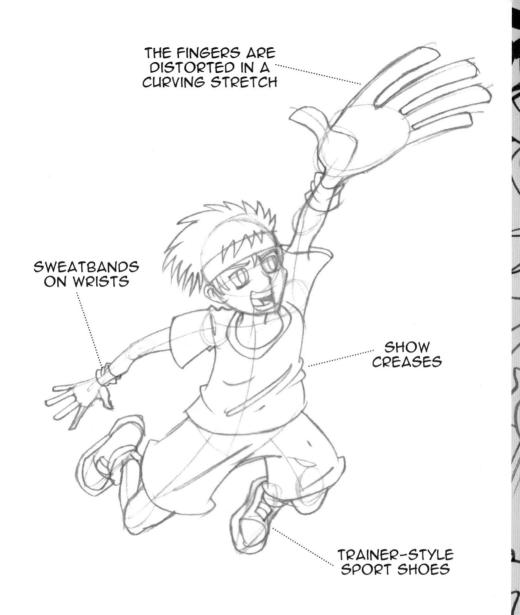

Flesh out your figure and add shoes, sweatbands and a loosefitting t-shirt and shorts...

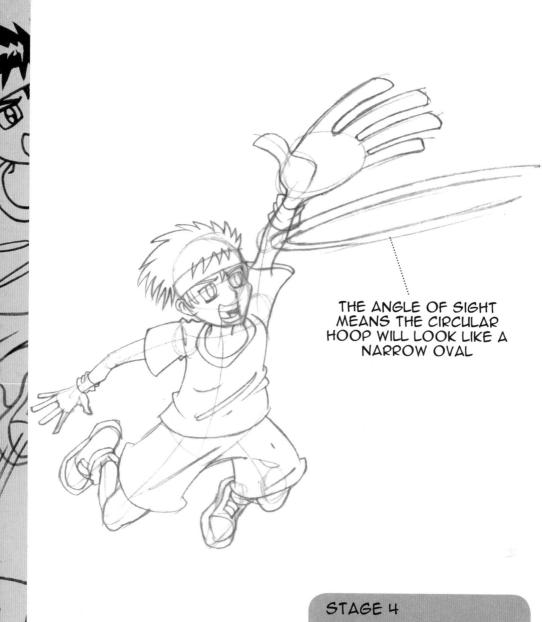

Draw an ellipse shape under the hand for the basketball hoop...

THE BALL DOESN'T HAVE TO BE A PERFECT CIRCLE -A MOVING SPHERE CAN BE SLIGHTLY DISTORTED - SO DRAW IT FREEHAND

STAGE 5

Add a circular basketball shape dropping through the hoop...

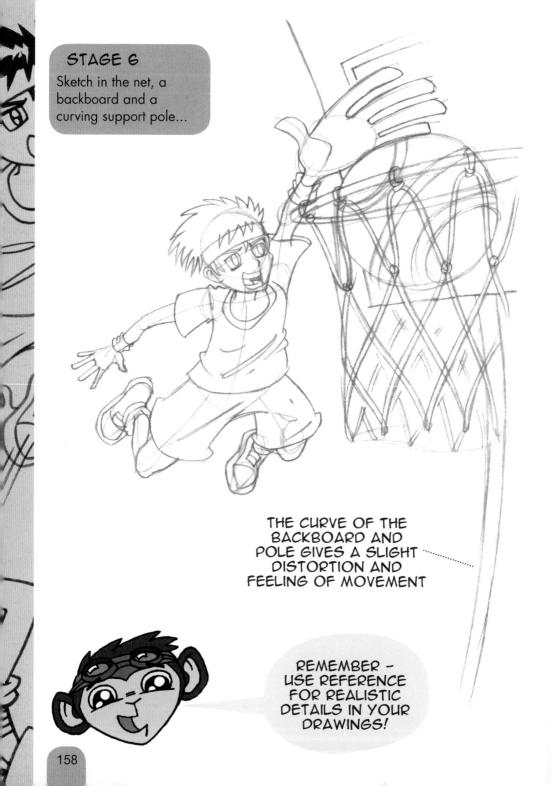

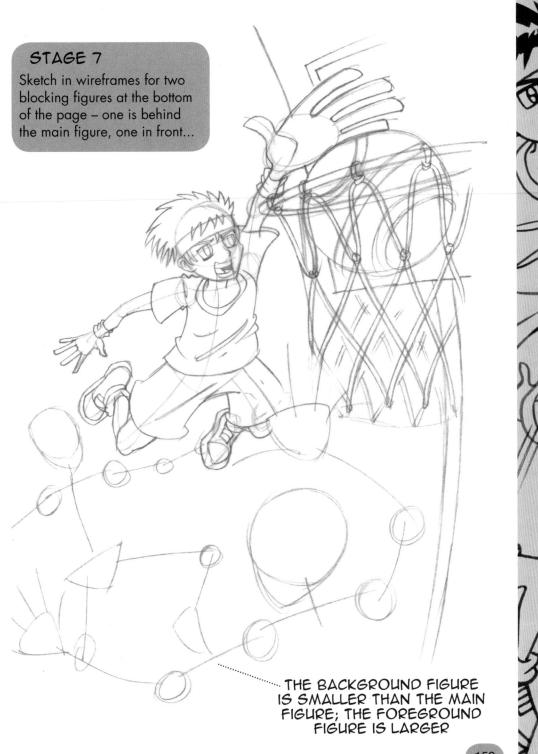

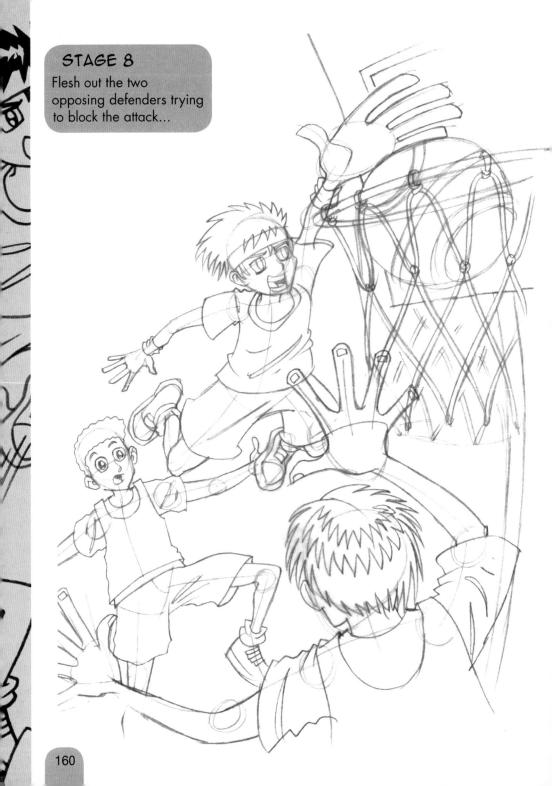

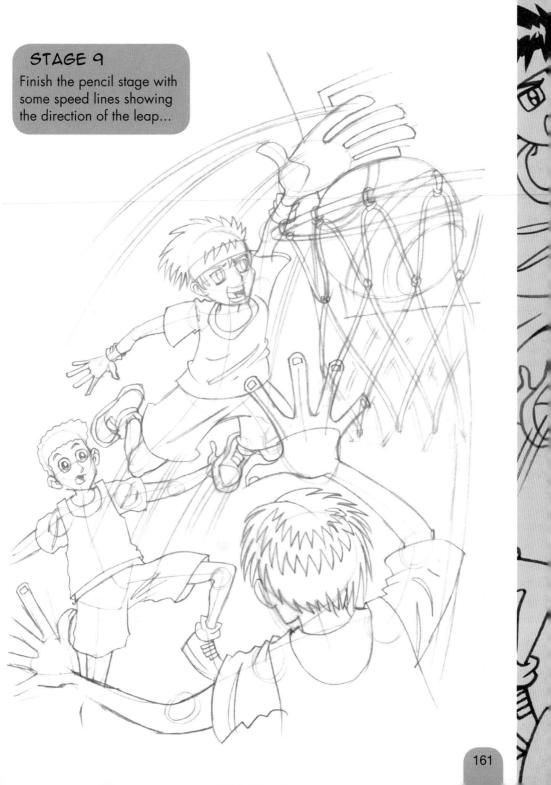

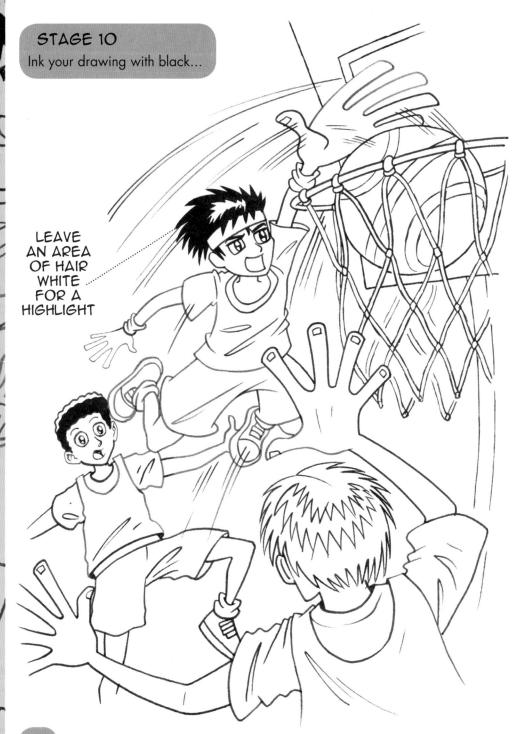

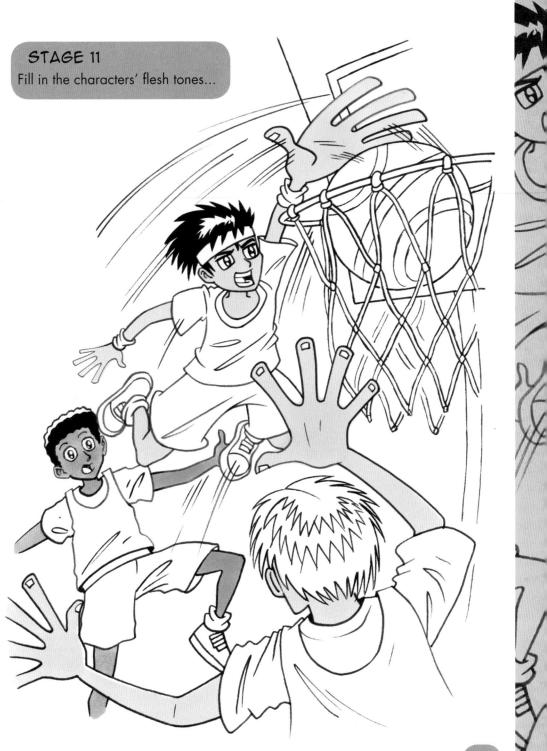

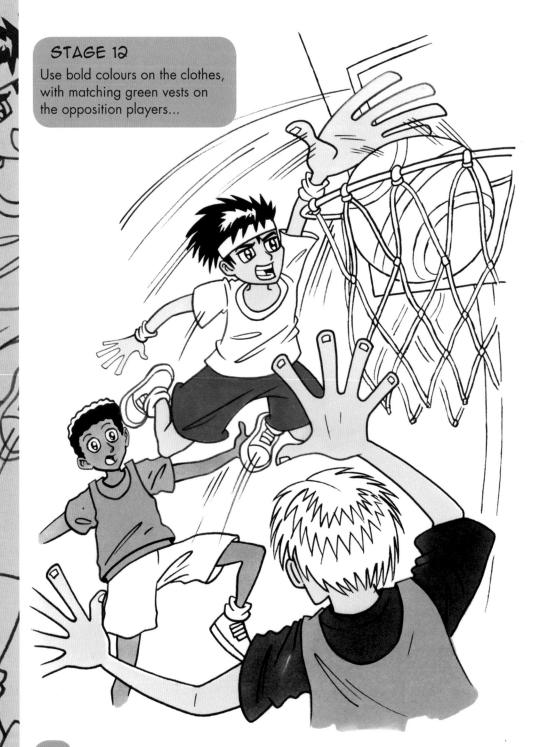

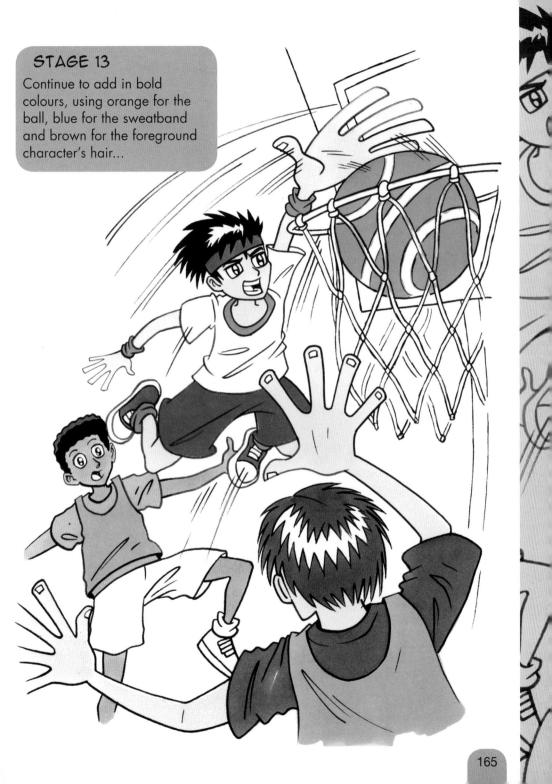

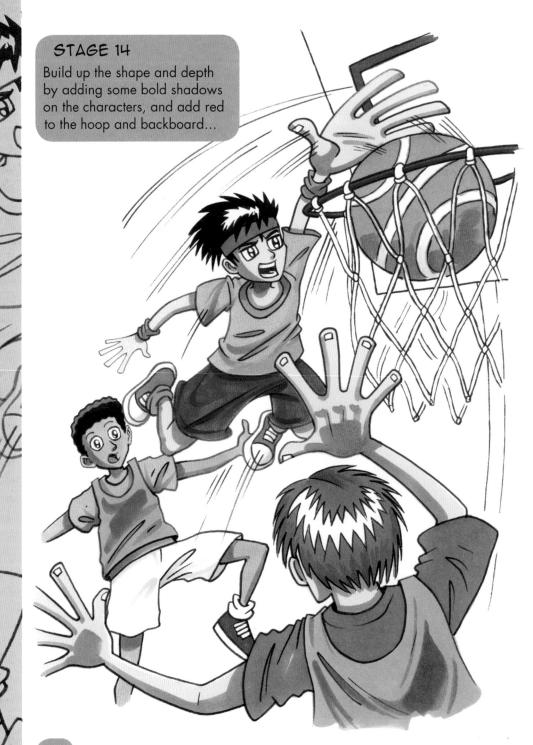

Finish with more shading, warm beige strokes to the background, and colour on the speed lines. Tidy any colour bleed with white bleed-proof paint and add in a few white highlights.

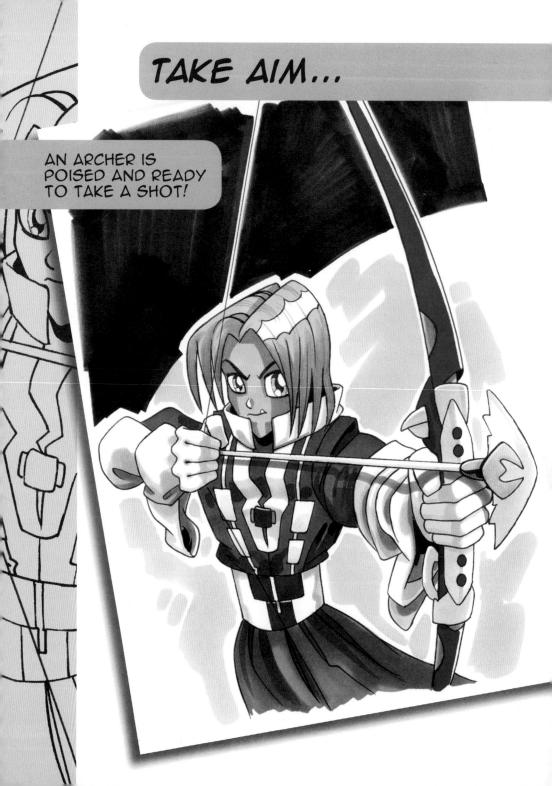

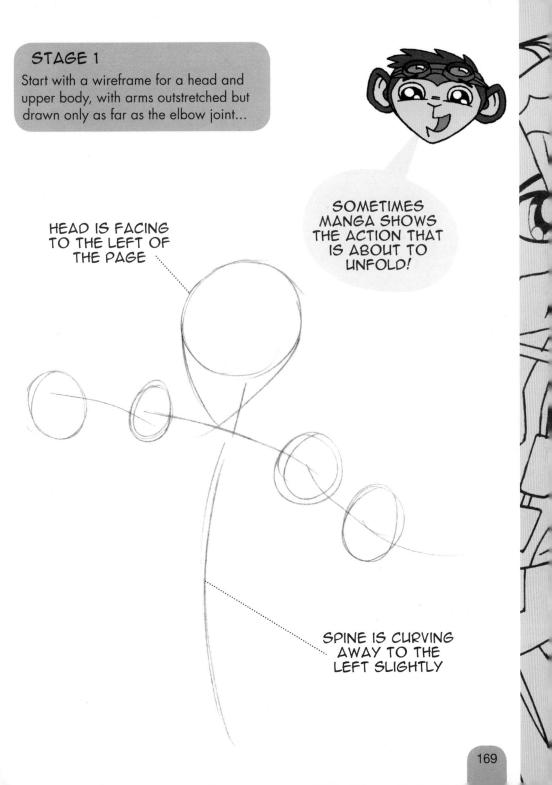

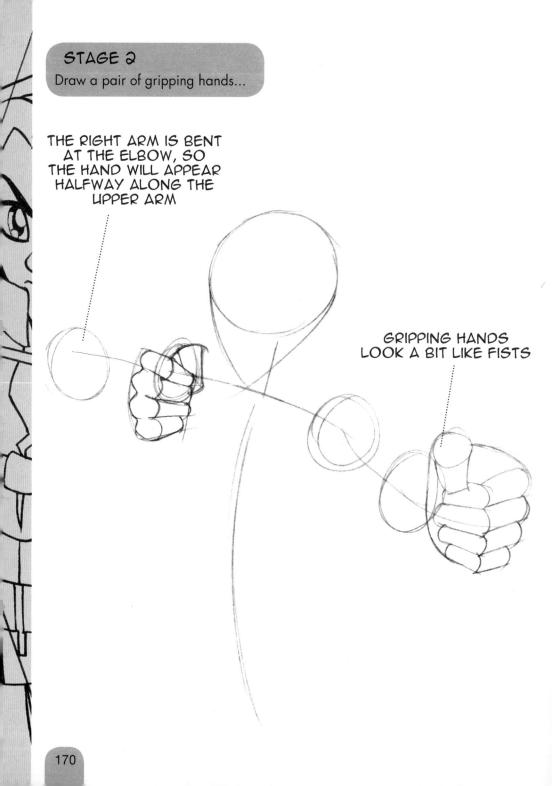

Flesh out the arms, creating sleeves of loose, baggy material...

SLEEVE GAPING OPEN AT THE CUFF

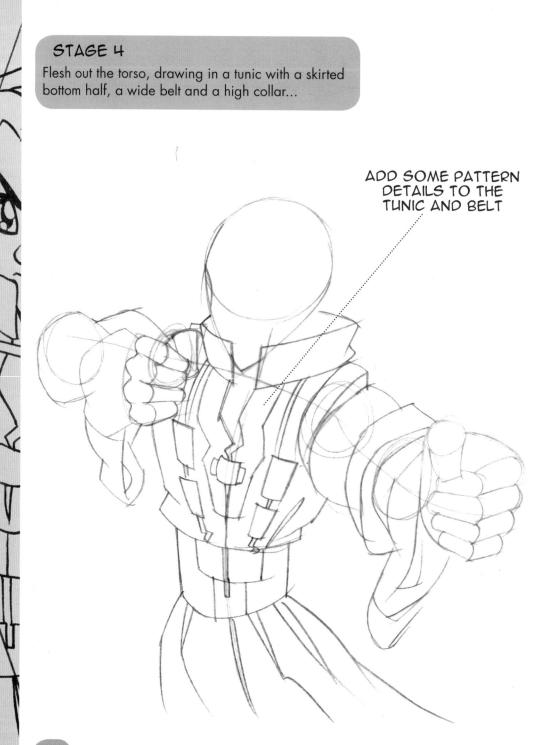

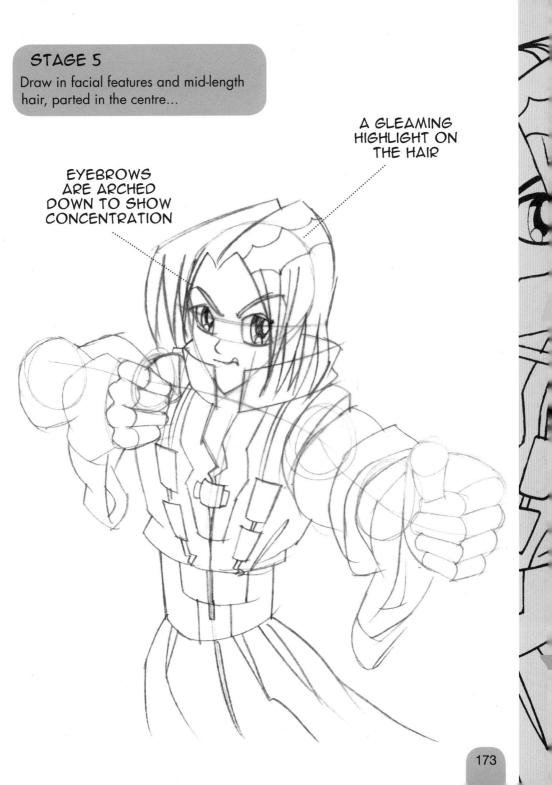

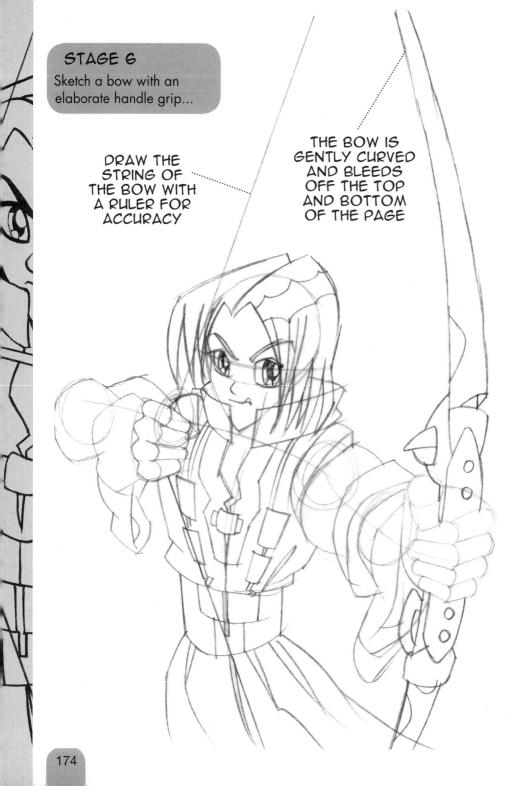

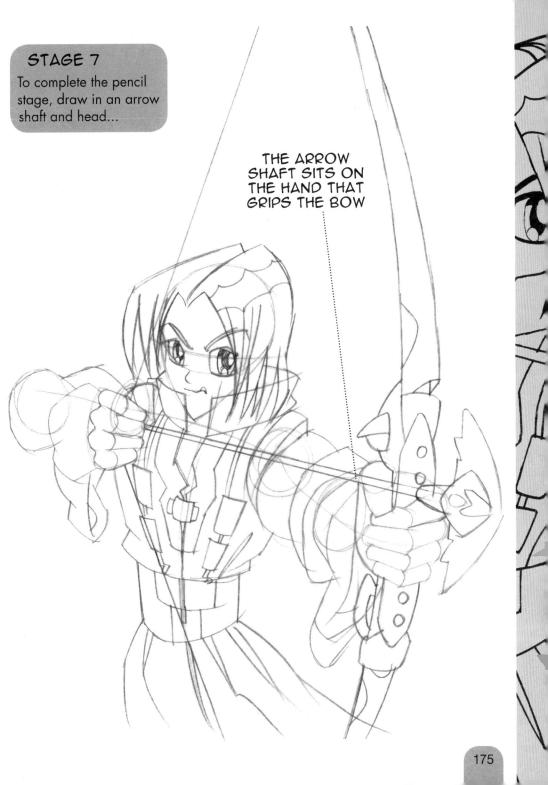

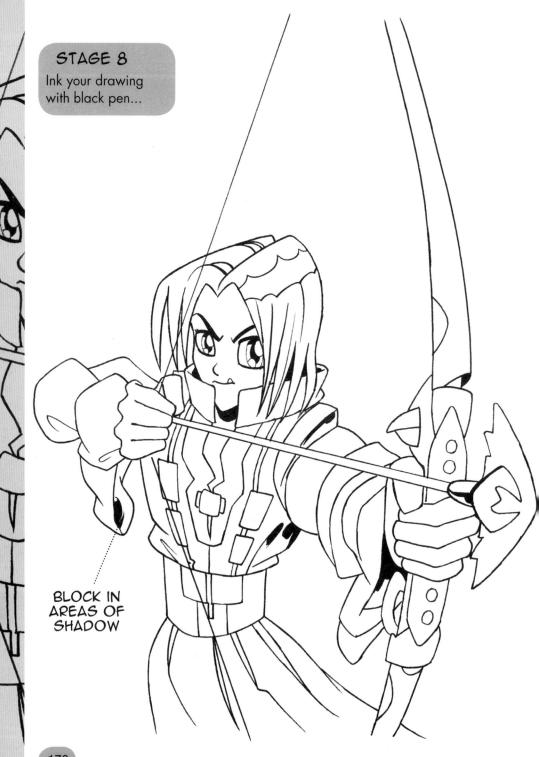

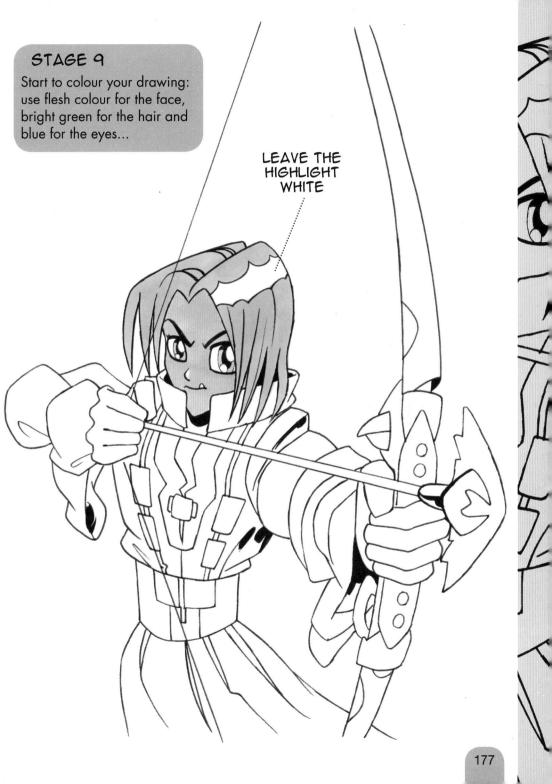

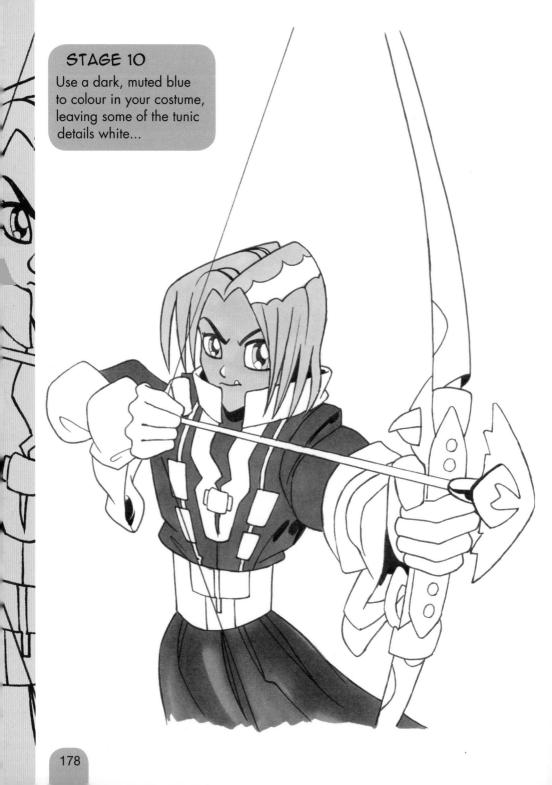

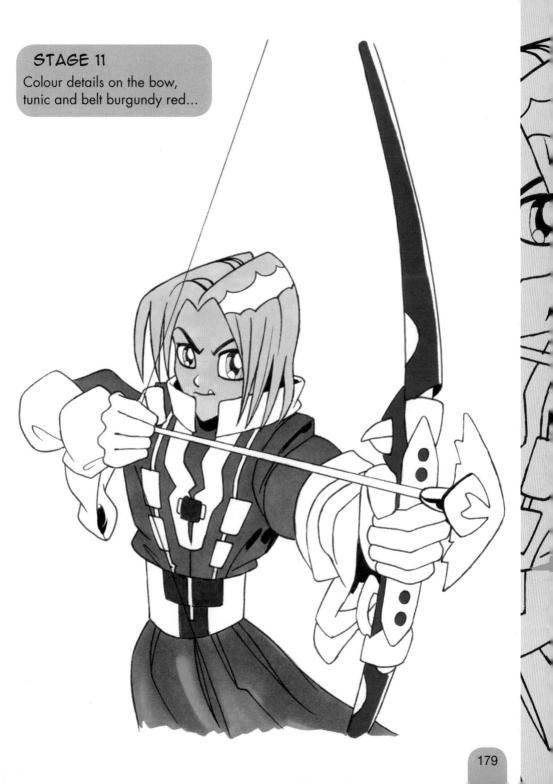

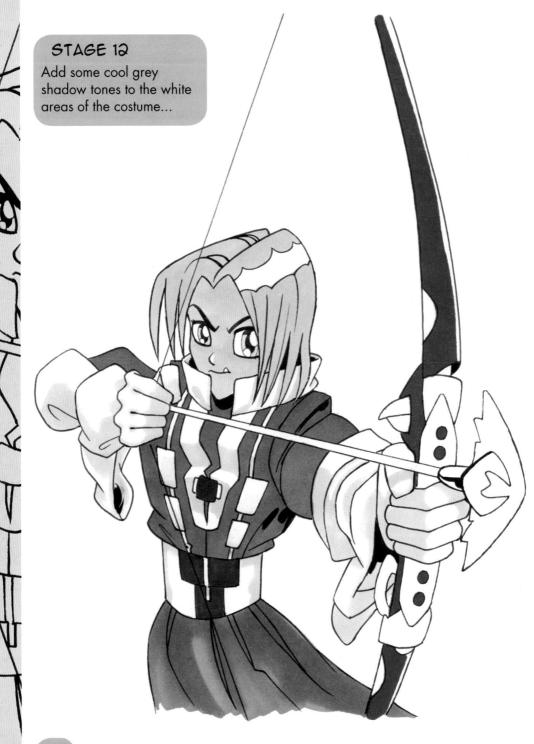

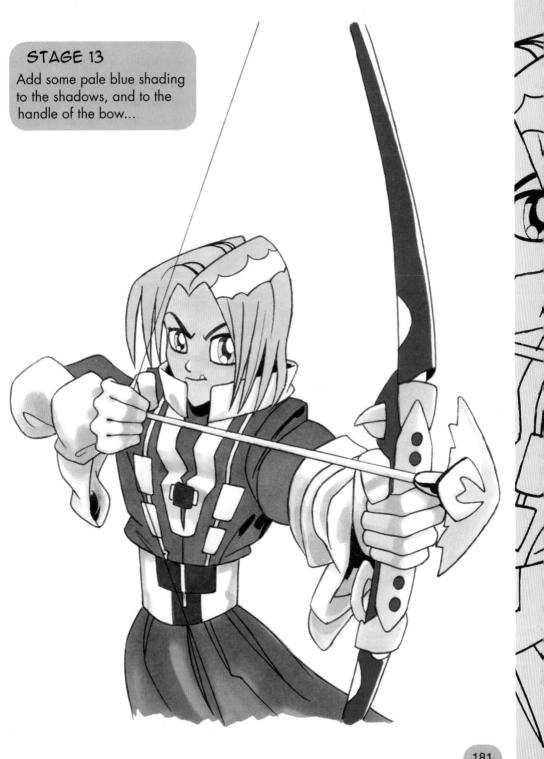

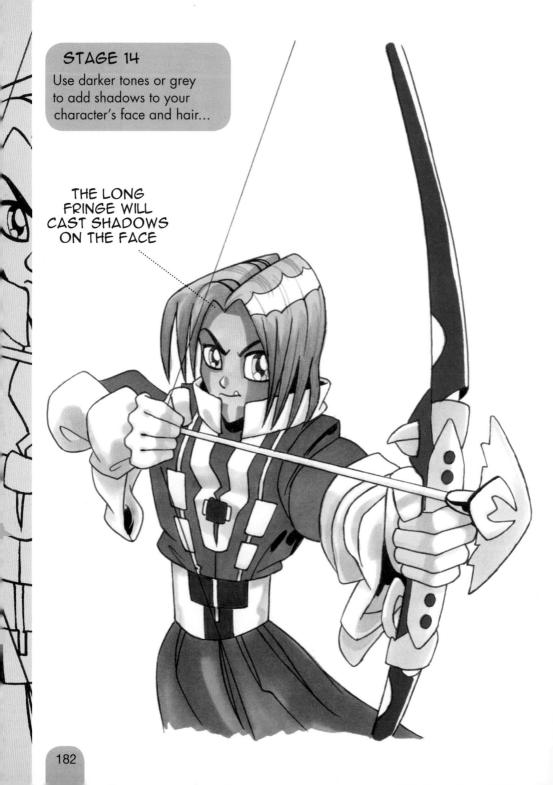

Use a cool orange to finish the detail on the bow. Use dark greys and blues to add further shadows to the tunic and gloves, and create the shadow of the arrow shaft along the character's chest and arm...

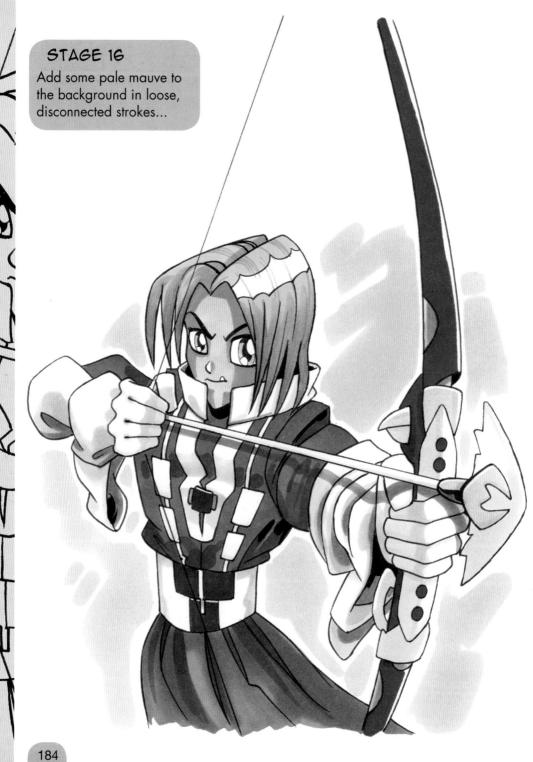

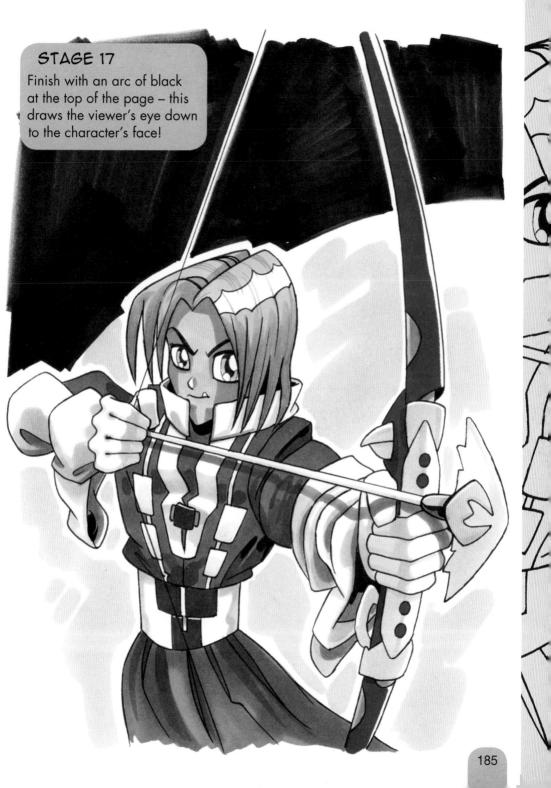

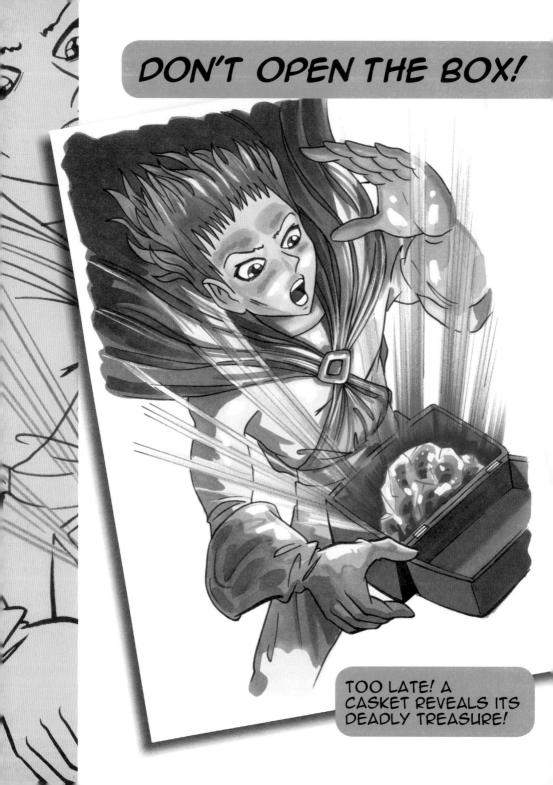

STAGE 1 Draw a wireframe head, upper body and arms that fill most of the page...

RIGHT HAND EXTENDS TOWARDS THE BOTTOM OF THE PAGE - DON'T DRAW IN THE

Sketch in the character's hair and face. Draw an open mouth and a surprised expression, with the eyes looking down to the bottom right of the page...

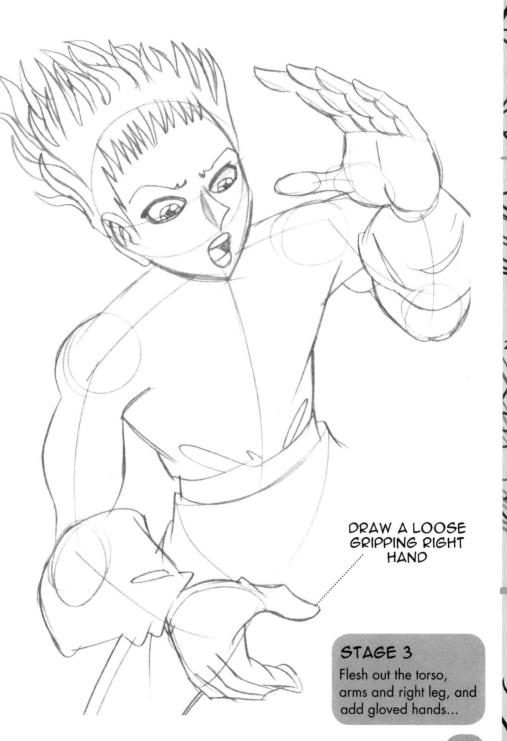

Draw a casket with an open lid, revealing a jagged piece of rock...

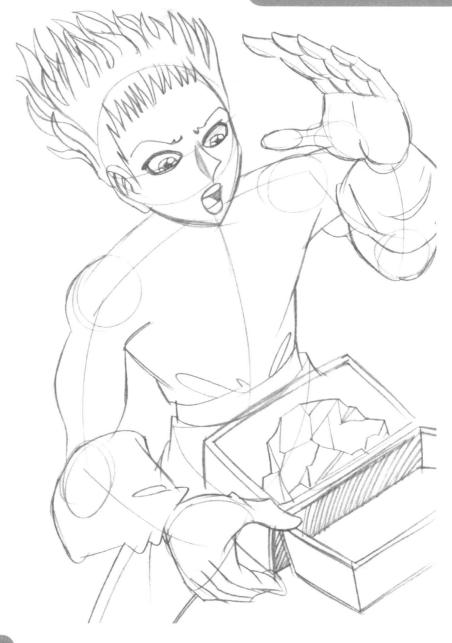

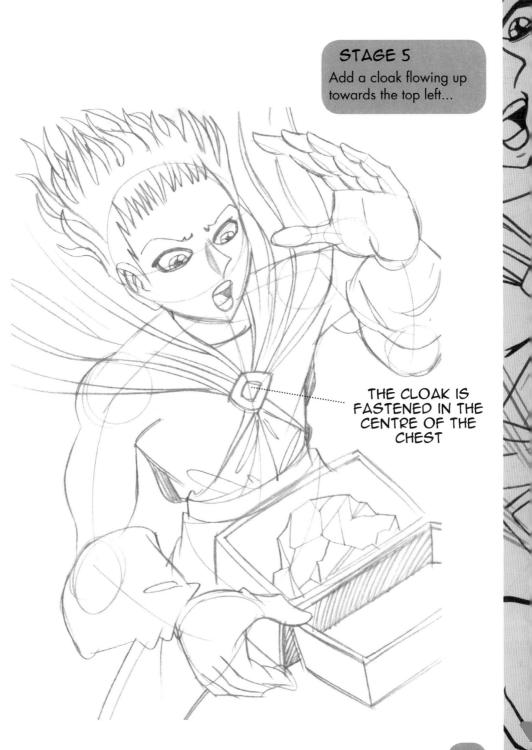

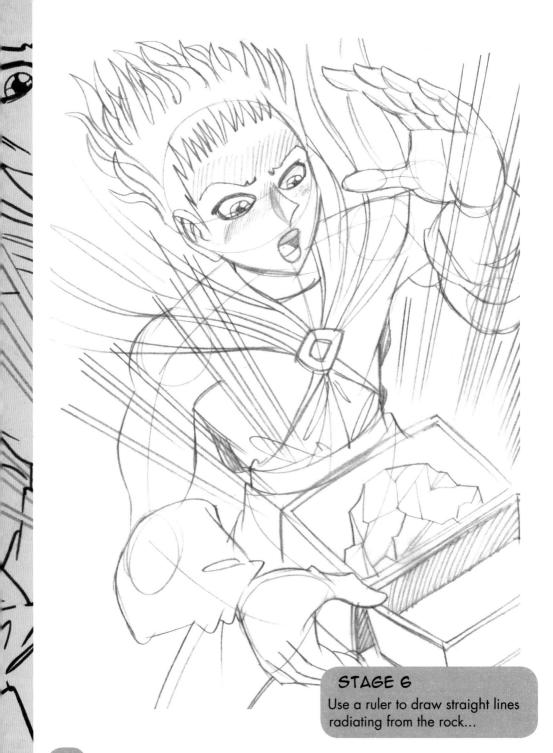

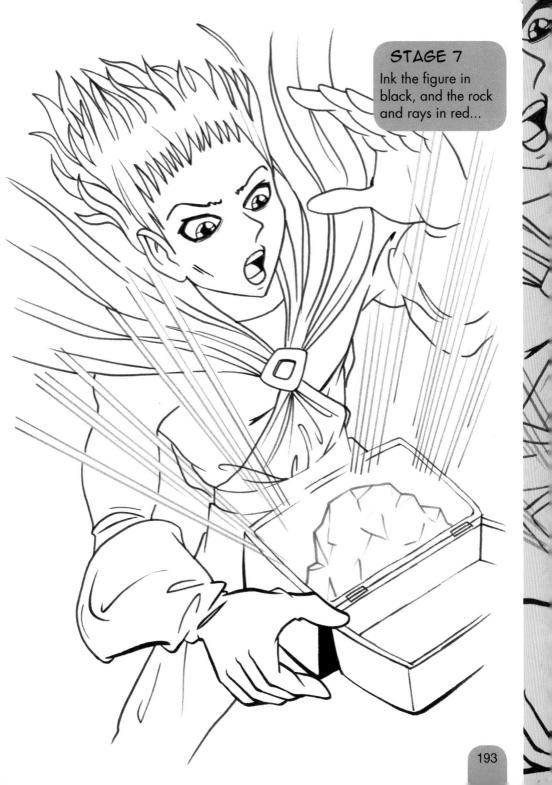

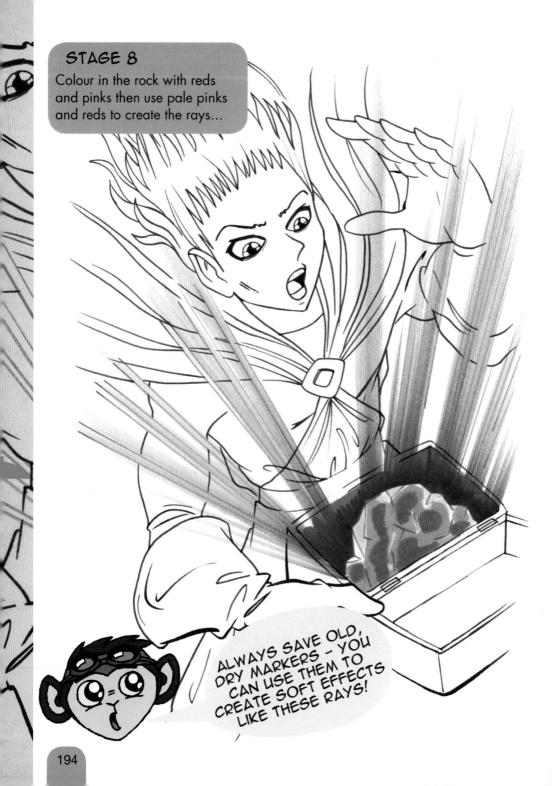

Te

Add flesh tone to the face, leaving white highlight areas, and use mid-grey and pink on the gloves... 07

TA

Use dark grey on the hair and red on the tongue, and use a midgrey to darken the face colour...

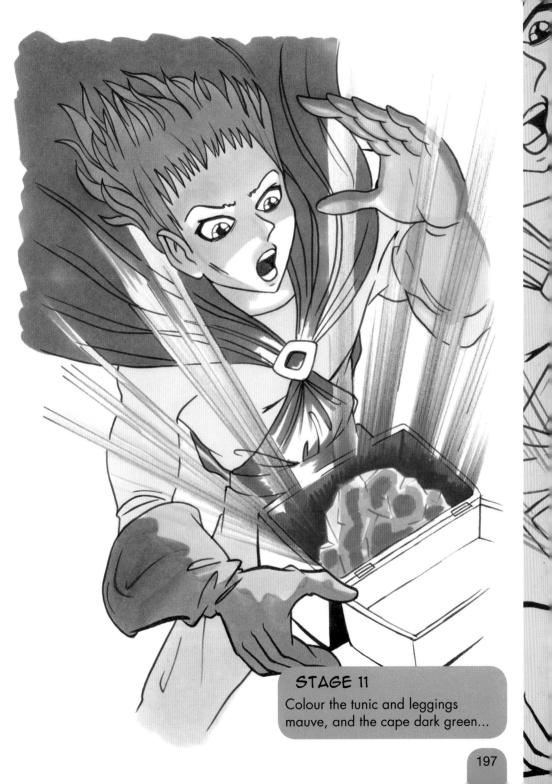

6

Add a darker grey tone to the outer edges of the tunic and leggings. Use this to help define the shape of the body...

Colour the casket with brown tones. Add red to the eyes and pink to the highlights on the face and cape to reflect the glow of the rock. Add some darker tones to the gloves and add some dark green streaks to the front of the cape...

T

Build up the colour on the cape and hair with darker tones, and add deeper shadows to the face...

Finish with some small areas of white paint on the hands, rock and clothes, to add extra punch to the highlights.

C

1 / A

07

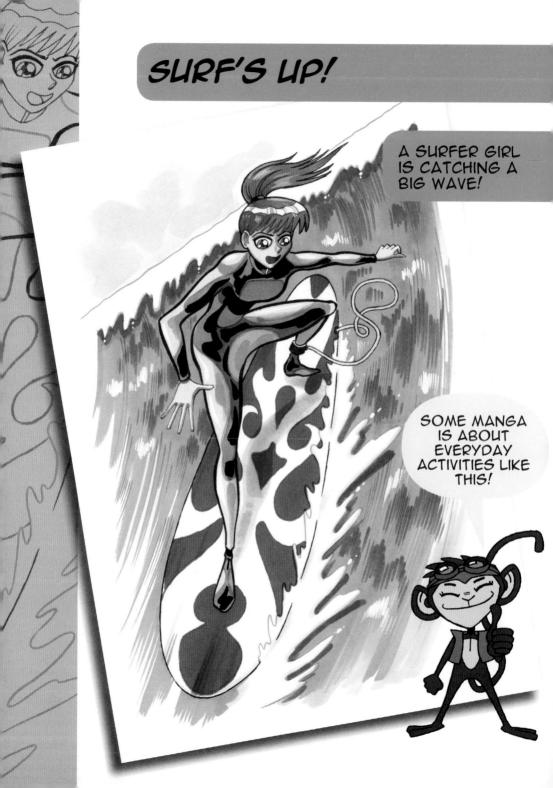

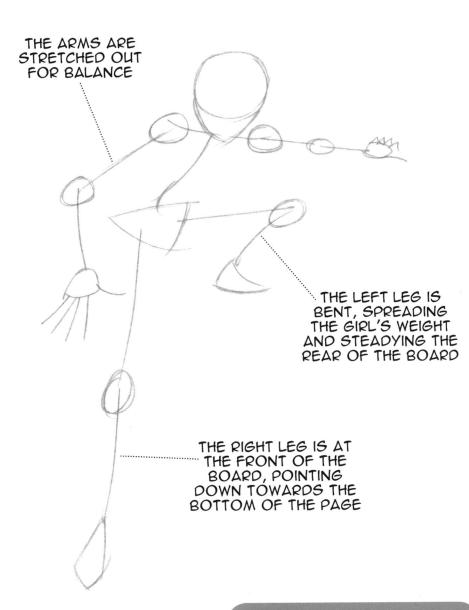

Start by creating a crouching wireframe figure in the centre of the page...

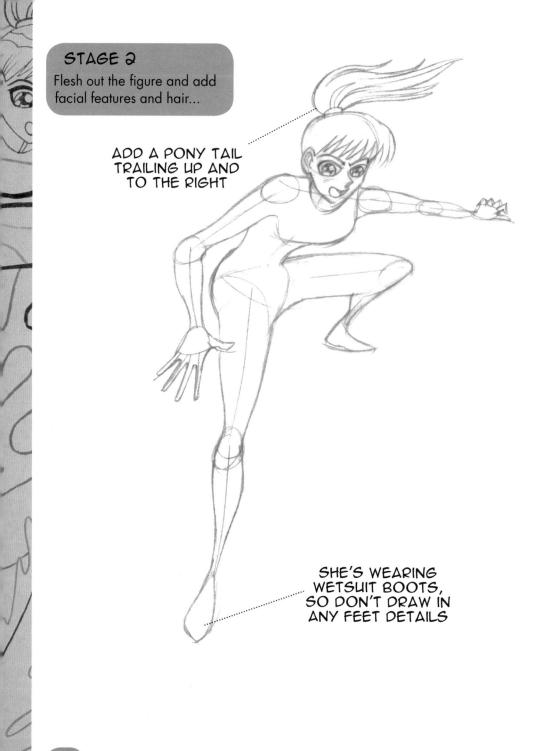

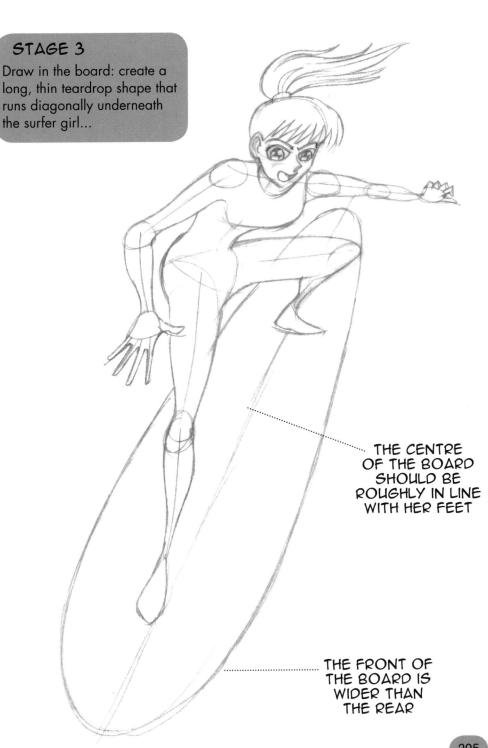

Draw the lip of the wave running diagonally from the top right of the page, down to roughly the level of her right elbow...

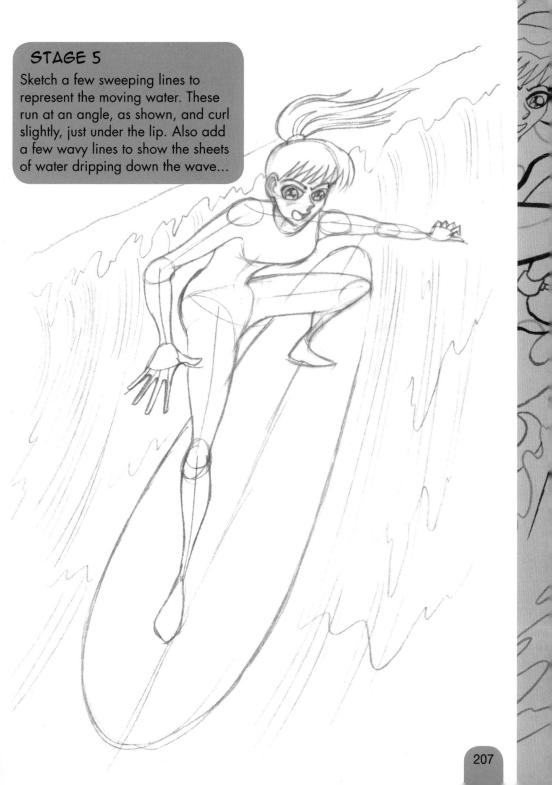

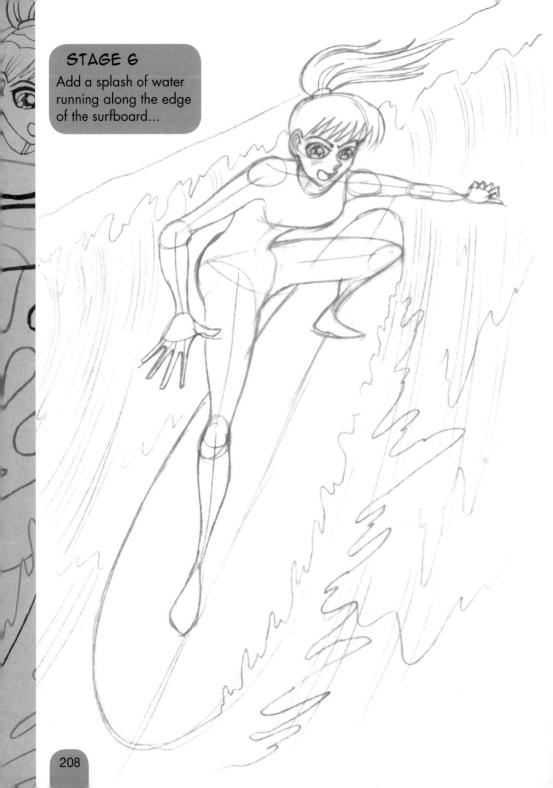

Draw some details on the wetsuit and add a cord attaching her ankle to the board...

> THE CORD HELPS TO AVOID LOSING YOUR BOARD IN A WIPEOUT!

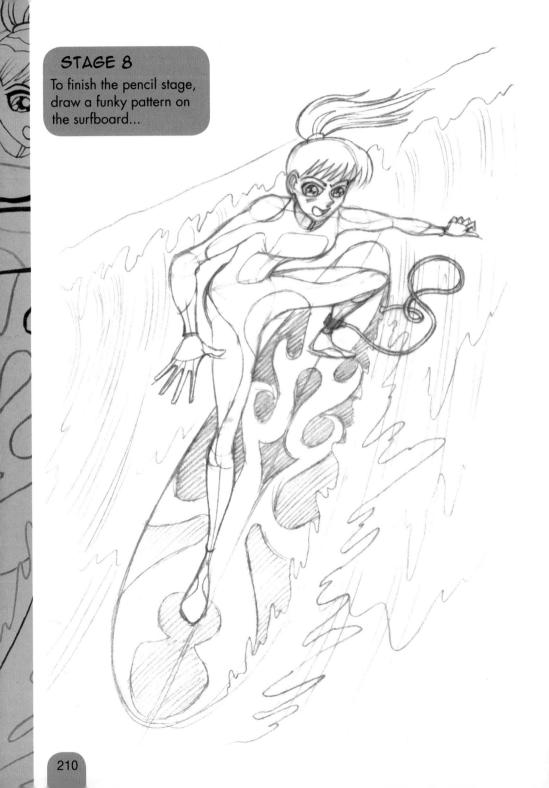

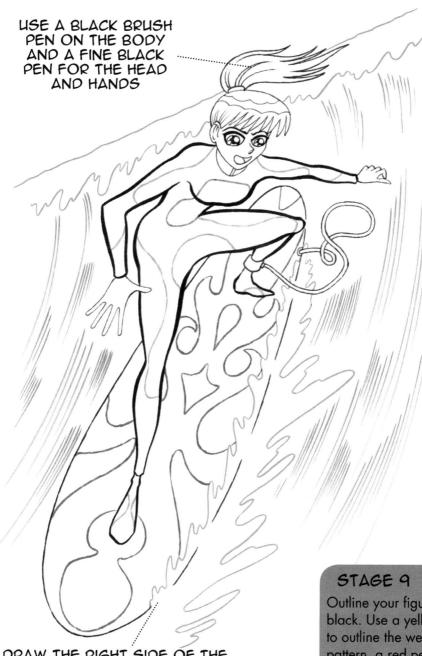

DRAW THE RIGHT SIDE OF THE BOARD AS A BROKEN LINE, TO SHOW THAT WATER IS SPLASHING OVER IT Outline your figure with black. Use a yellow pen to outline the wetsuit pattern, a red pen for the board design and a blue pen for the water...

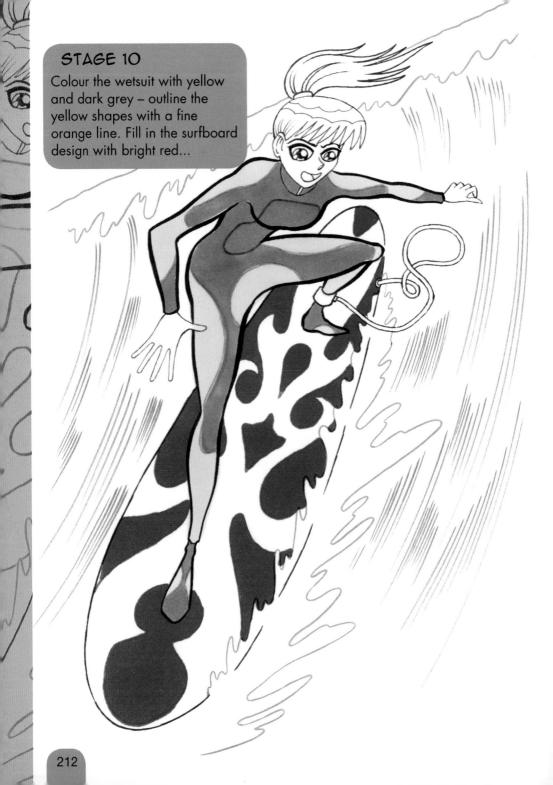

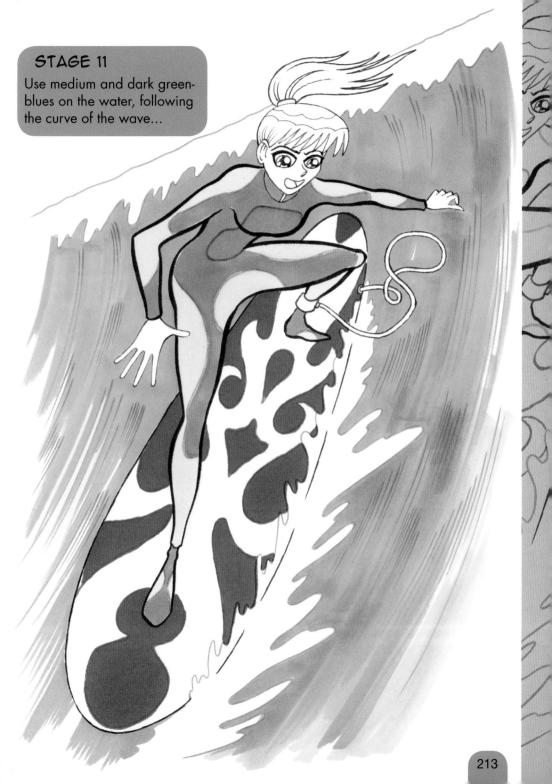

STAGE 12 Add flesh colour to the face and hands and orange to the hair. Use darker tones to add shading to the face, hair and body...

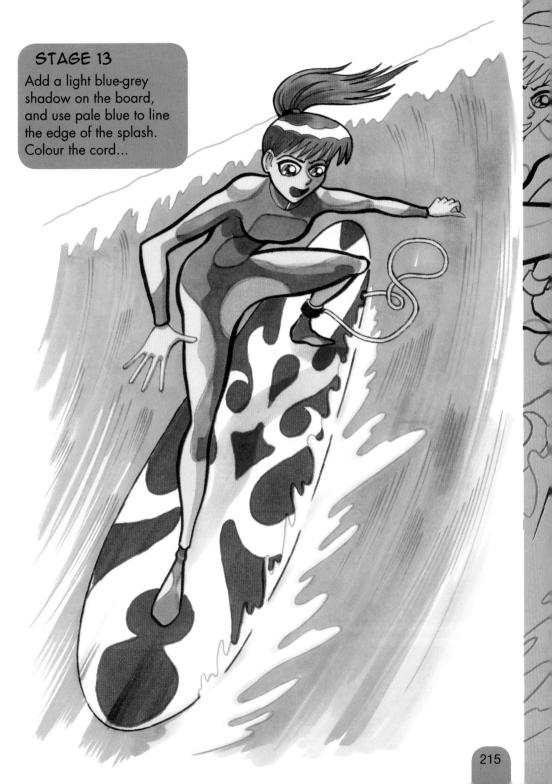

Add some darker blue tones to the water and under the lip of the wave and splash line. Colour the sky area with mid-grey and pale blue...

Finish by adding some solid blacks to the figure and white detailing on the water to make your drawing really pop!

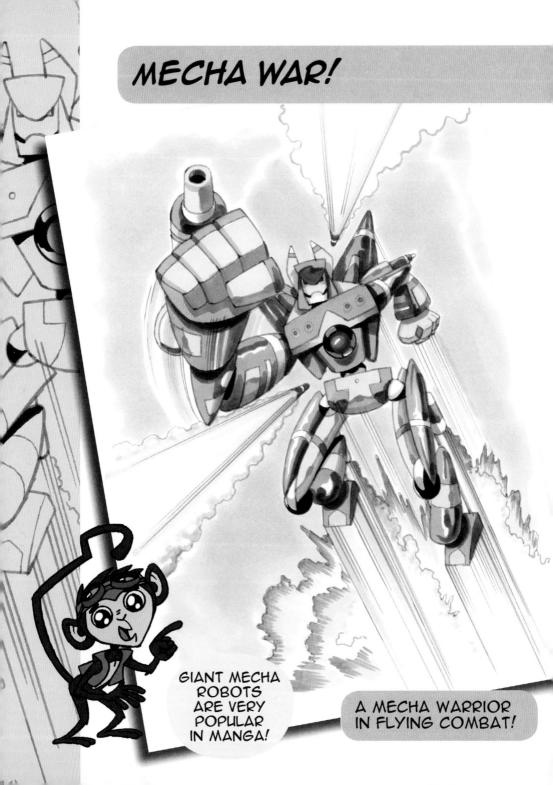

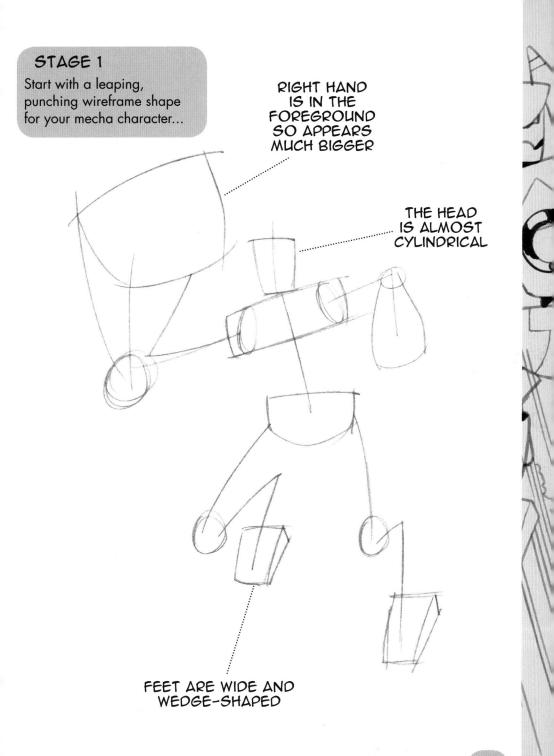

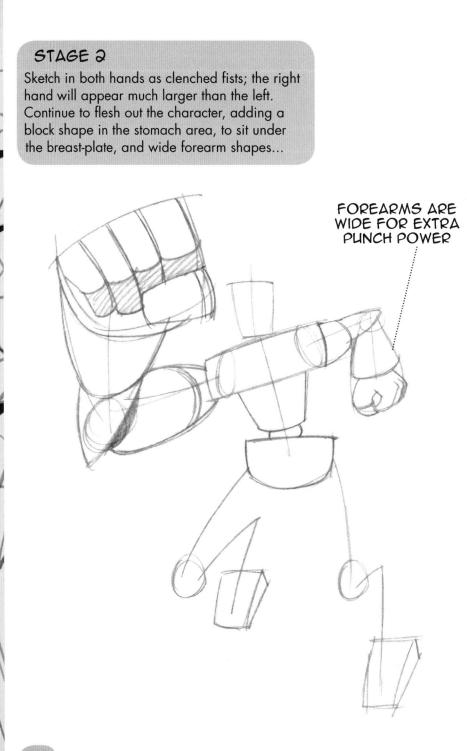

Create curving upper and lower leg shapes. Keeping the sections detached slightly from each other gives a robotic, non-human appearance...

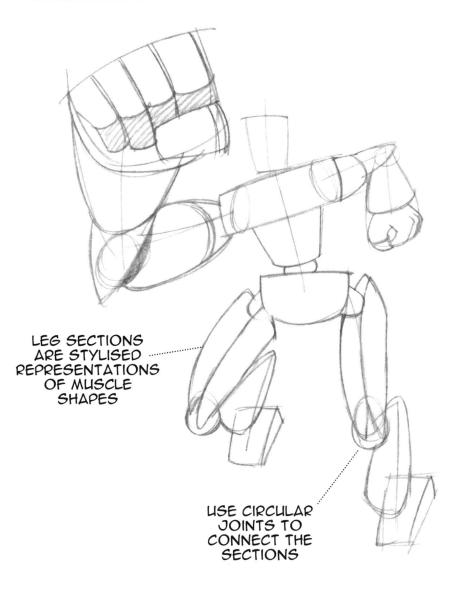

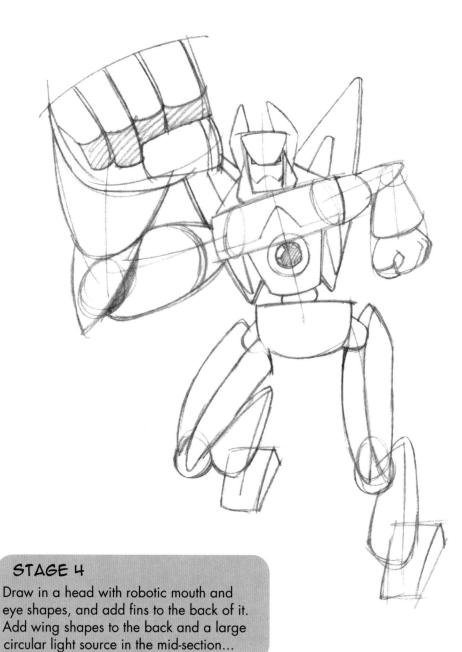

STAGE 5 Draw in blasters above the right hand and

running along the left arm. Add downwardpointing thrusters on the backs of the thighs, and markings on the character's hips...

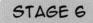

Draw an explosive blast beneath the feet, and speed lines pushing the figure upwards...

Draw two projectiles blasting towards the figure. Note how the blast trails widen as they reach the edges of the page....

Ink the drawing. I've used a grey pen for the outline to give a softer edge and to make the object look as though it is far in the distance. Fill in solid areas of black shadow...

0

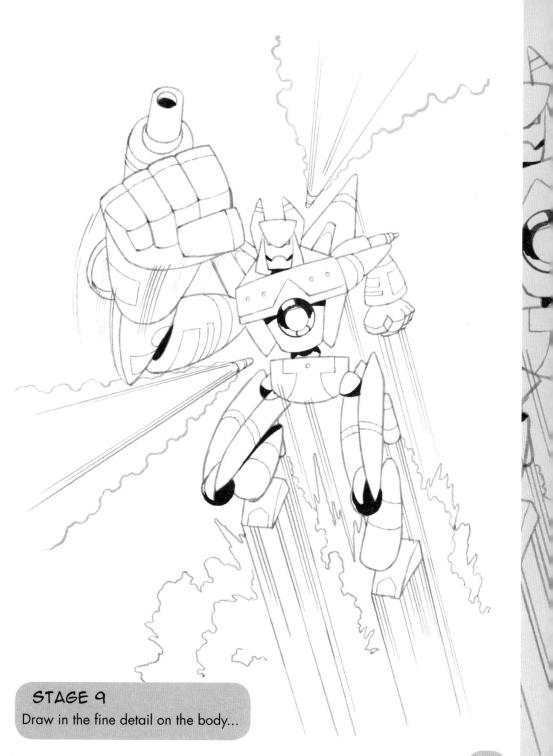

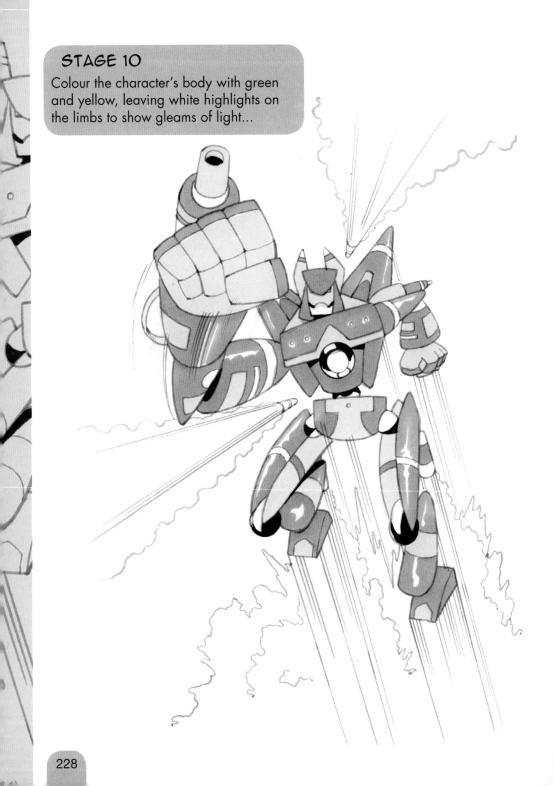

Use dark green and golden yellow markers to add some shadows to the character and give it more shape...

Darken the shadows by reapplying the same colours, or using darker shades. Colour in the chest light with red and orange...

S

S

Colour in the sky with a few shades of pale blue, using small, quick marks to give a varying tone...

Use yellow and orange to edge the blast streams and explosion. Edge the smoke with greys...

Finish by adding a final shade of dark green to the body work!

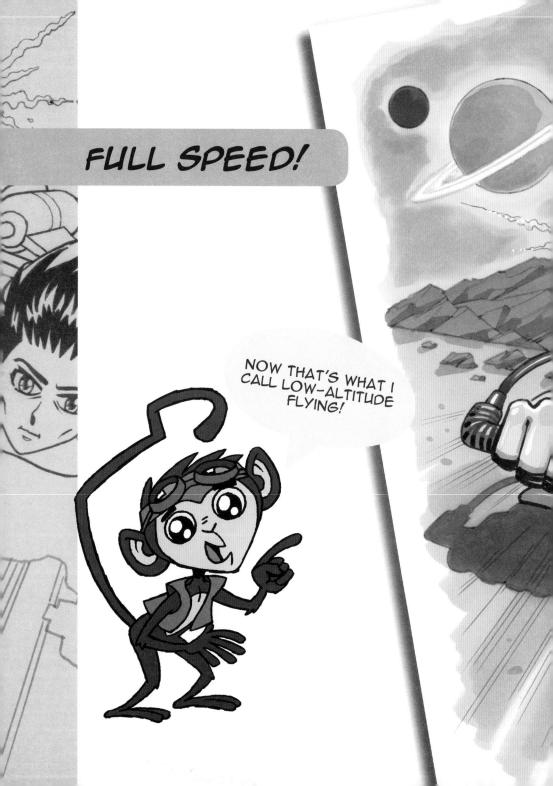

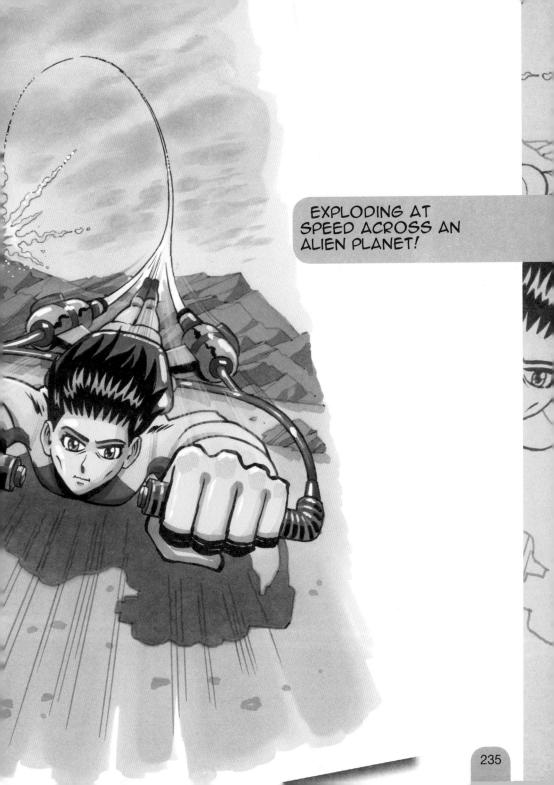

STAGE 1 Begin by drawing a wireframe head and shoulders in the lower half of the page, with two large shapes for fists... THE FISTS ARE LEADING THE ACTION THE ARMS ARE SO THEY'RE BIGGER STRETCHED OUT IN FRONT, MAKING THE THAN THE HEAD SHOULDERS AND ELBOWS APPEAR VERY CLOSE TOGETHER

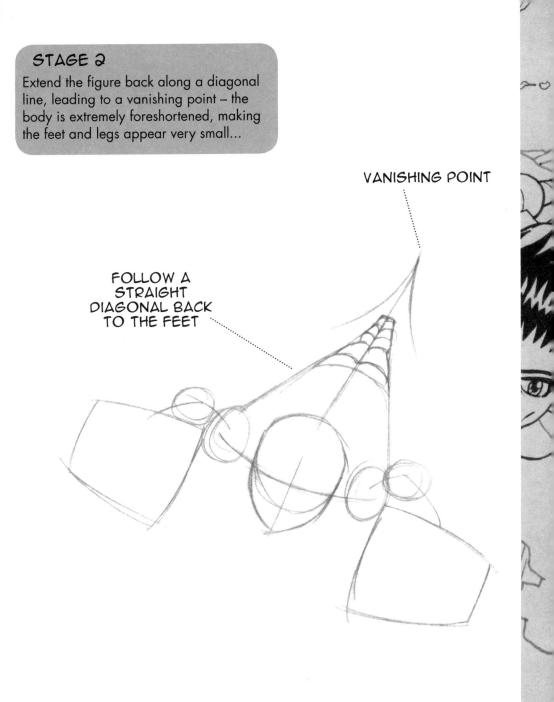

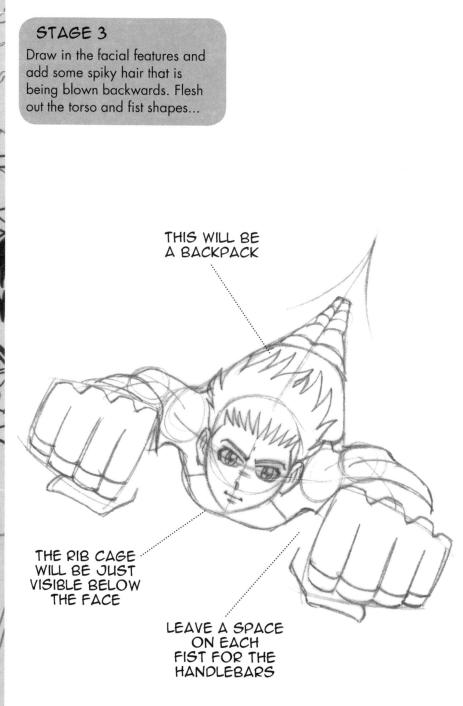

Construct the flying harness: draw handlebar attachments connected to the backpack by tubes, with rocket boosters on either side...

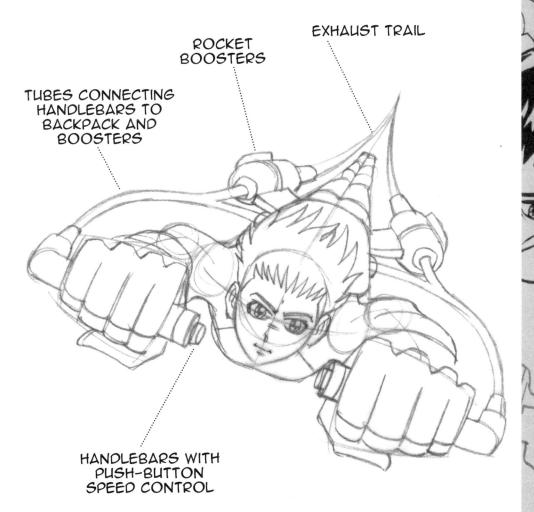

STAGE 5 Sketch a diagonal horizon line with a rocky mountain range in the distance...

A DIAGONAL HORIZON CAN ADD A FEELING OF DYNAMIC ACTION

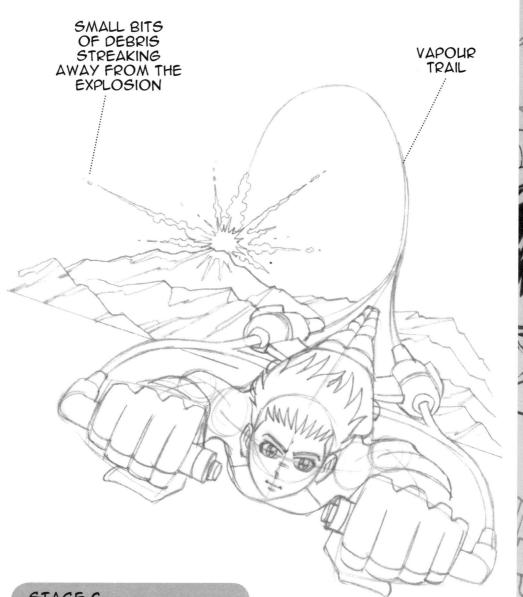

Add an exploding departure point on the tallest peak, with a vapour trail leading up and down, before connecting to the boosters... 9

USE A COMPASS OR CIRCLE GUIDE FOR THESE SHAPES

STAGE 7

To give an impression of an alien landscape, draw a ringed planet and a small moon in the sky. Sketch some scattered rocks on the surface, and add speed lines and a shadow underneath the figure...

Ink your figure with black and the background with grey – this will make the figure jump out of the picture...

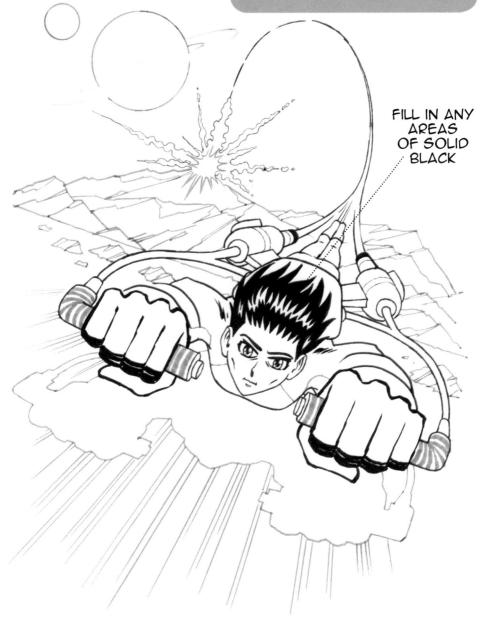

0,/

Colour your alien sky with mauve and pale grey clouds. Use pink tones on the large planet and red tones on the small one...

STAGE 10 Use a dark blueberry colour

Use a dark blueberry colour on the mountains, and mauve on the ground... D. V

STAGE 11 Use a dark grey to create shadows on the mountains and underneath the figure...

Colour the figure's face and hands with flesh tones and the suit in red and yellow. Add shading using darker tones...

1

Ø.

Colour the tubes and booster details red and grey, and add yellow and orange to the mountain blast...

Finish by adding some black shadows and white highlights, then add some faint speed lines behind the figure using coloured pencils.

HEAT OF BATTLE

A CLOSE-UP ENCOUNTER WITH A STEELY-EYED HERO IN THE FIGHT OF HIS LIFE!

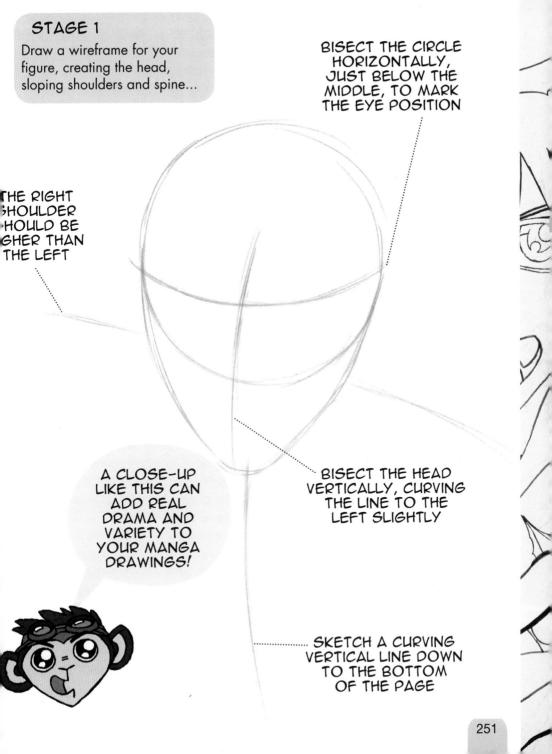

STAGE 2 Sketch in the facial features, including some angry-looking eyes and an open mouth... PUPILS HAVE TWO WHITE

DRAW A WIDE MOUTH IN THE LOWER PART OF THE EGG SHAPE, WITH CONCAVE HORIZONTAL LINES

HIGHLIGHTS

INDICATE TWO SMALL NOSTRIL SHAPES AND A SMALL POINT TO THE NOSE

Add some ears and a strong, angular jawline...

THE JAWLINE IS SHARP AND ANGULAR

THE EAR ON THE RIGHT SIDE SHOULD BE SLIGHTLY LOWER THAN THE LEFT, TO INDICATE A TILT OF THE HEAD

THE HAIR GROWS OUT FROM A CENTRE PARTING

THE FRINGE FALLS DOWN BELOW THE EYELINE

THE TEETH AT EITHER END ARE POINTED, INDICATING ANGER OR DETERMINATION

STAGE 4

Draw long, spiky hair falling down around the face on either side and add in some teeth...

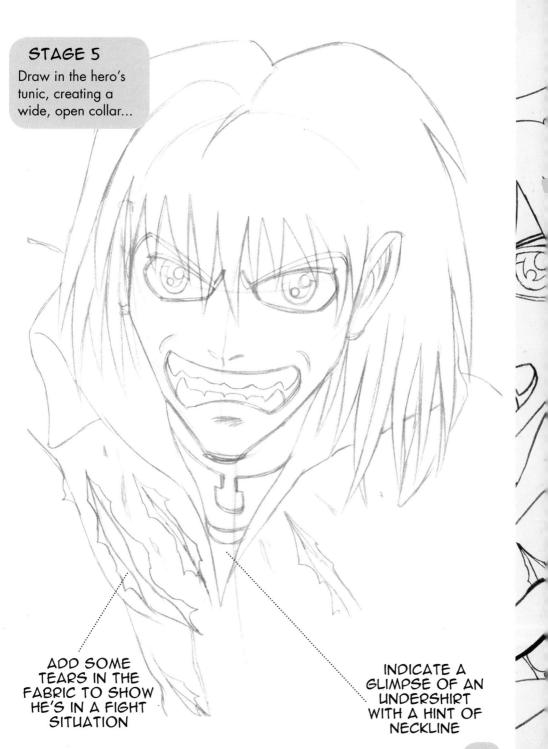

Sketch in a wireframe shape for an outstretched hand in the bottom right of the page, then flesh it out...

SHOW THUMB PARTLY CONCEALED BY FINGERS

AMANG/ AVI/
STAGE 7
Ink your drawing in black and add a jagged shape across the hair for a highlight

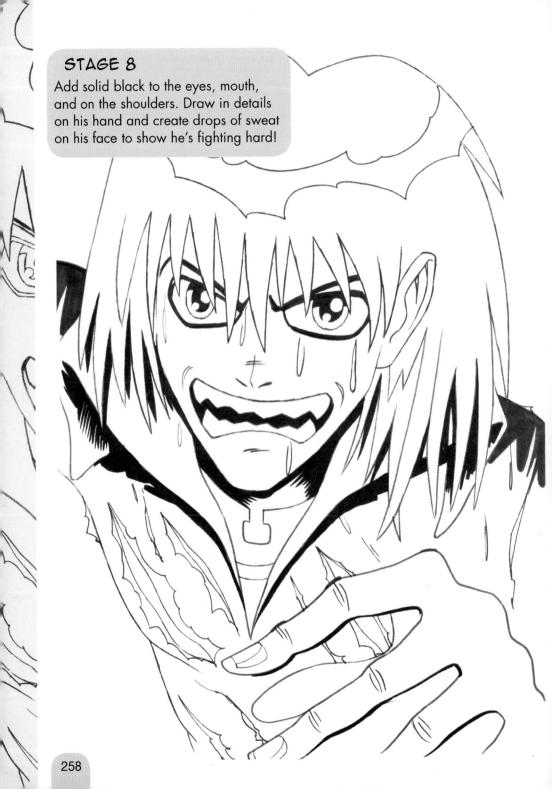

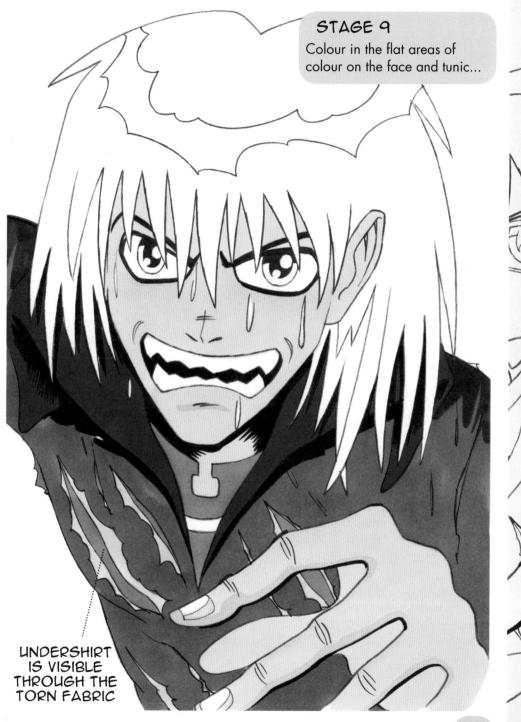

Colour the hair a dark grey, and eyes a bright green...

STAGE 11 Use darker flesh tones on the face and hands, to give an 'uplight' effect...

Colour in the background with a strong orange to bring heat to the drawing. Add some grey texture lines to the hair...

Finish with some textural shading in the large areas of colour, using darker shades. Use a purple pencil to add detail and colour to the hair.

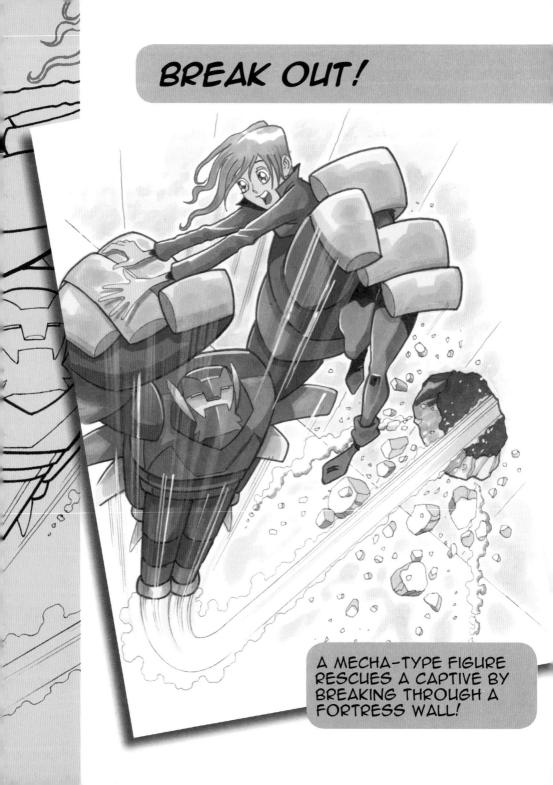

Draw four straight lines coming from a vanishing point towards the bottom left of the page. About half way up the page and between the two outer lines, draw the torso of your mecha character: a rough square shape with rounded corners, with two lines below, as shown...

VANISHING

USE A RULER FOR THESE LINES

THIS PROJECT USES A MECHA-TYPE CHARACTER!

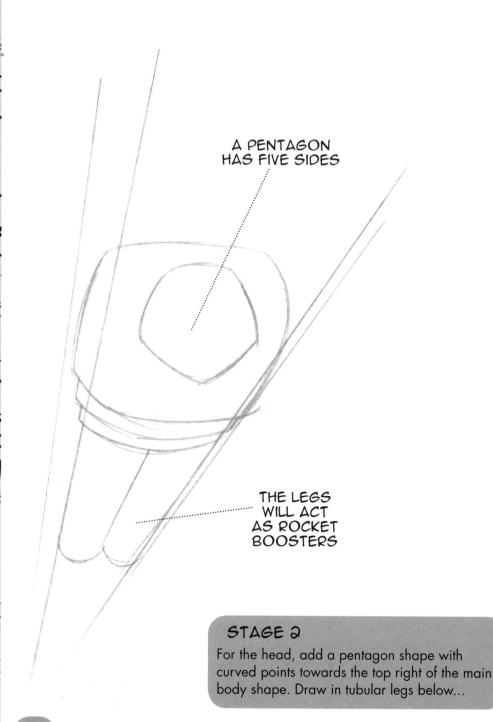

Add some back boosters and fins, and rims on the bottom of the legs, all following the perspective lines...

> THE TWO FINS SHOULD NOT BE QUITE LEVEL, AS THE BODY IS TWISTED AT A SLIGHT ANGLE

Draw some large, gripping hands that fill the top part of the page, and some stabilising fins coming from the back. Draw in some robotic facial features...

> STABILISING FINS HELP TO SUGGEST FLIGHT

Draw speed lines coming down out of the leg boosters and making a sharp turn across the bottom right of the page...

> LINES DRAWN WITH A RULER GIVE A FEEL OF HIGH SPEED

Draw a diagonal line to show where the wall meets the ground, then a hole in the wall around the speed lines...

THIS LINE SHOWS WHERE THE HORIZONTAL MEETS THE VERTICAL SHOW THE THICKNESS OF THE WALL AND ADD A DARK SHADOW FOR THE INTERIOR

ARMS ARE OUTSTRETCHED The mecha character is rescuing a girl from captivity – draw a wireframe for the top and bottom of her body, which is held in the figure's left hand...

RIGHT LEG

Flesh out the girl with long, straggly hair, a jacket, leggings and ankle boots. Give her an excited facial expression and outstretched fingers..

Add lots of rubble and broken rock bursting from the hole – the more the better!

tr

Ink the whole drawing with black except the girl's hair, which should be outlined in red. Use a thick line on the mecha character and a fine line on the rubble and speed lines...

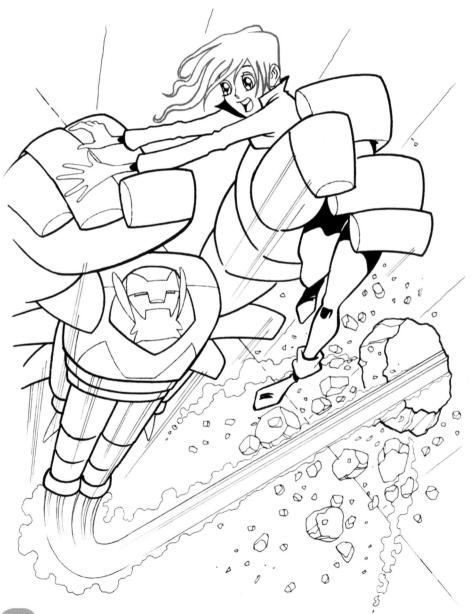

Start colouring the wall with a warm beige, and build up several layers of colour. Fill in the hole with black and grey...

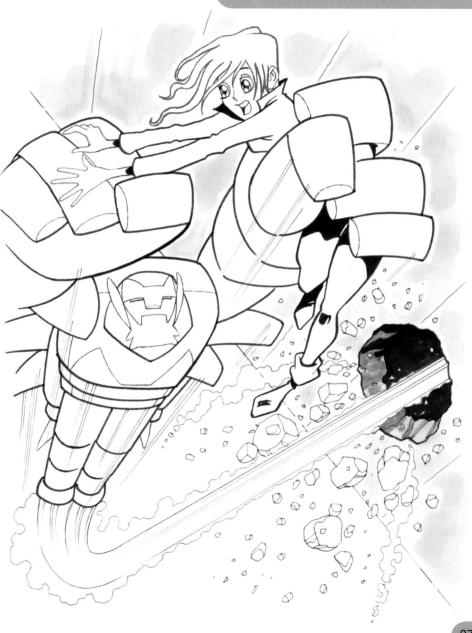

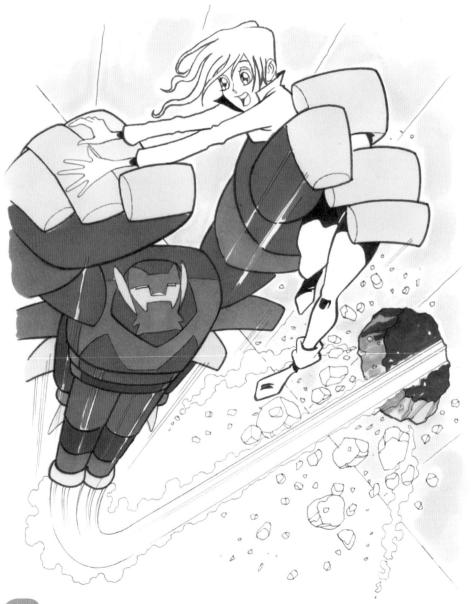

000

LEAVE AN AREA WHITE AS A HIGHLIGHT Colour the girl's jacket and boots brown and her leggings grey. Colour in her hair bright pink and add flesh tone to her face and hands...

0

Q

0 0 0 0[®] o 0 Ca 0 0 3 0 0 STAGE 14

Build up depth by adding darker tones and shading. Adding more than one layer of the same colour builds a rich warmth...

Finish by applying even more layers of colour and use white paint to pick out speed lines. Add speed lines on top of the figure with coloured pencils...

0

T

00

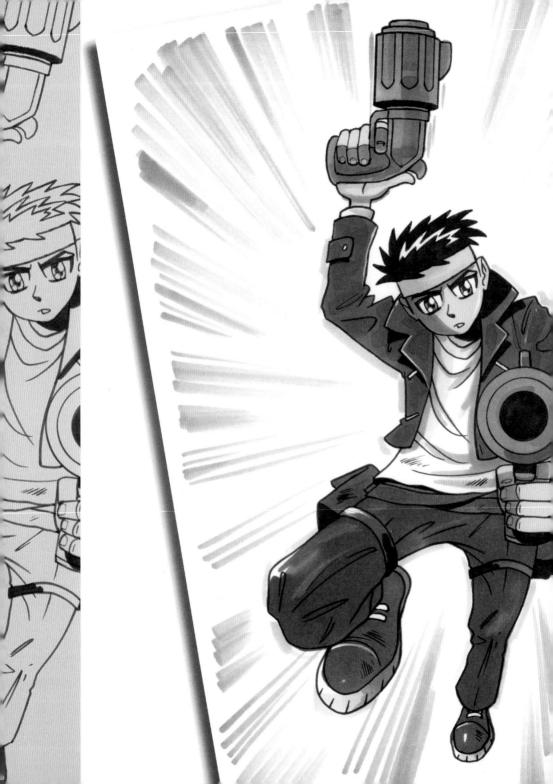

A TWO-GUN SALUTE COMING STRAIGHT AT YOU!

DRAWING A HAND HOLDING A GUN CAN BE TRICKY! USE YOUR MIRROR AND POSE WITH A TOY GUN TO HELP GET IT RIGHT!

Start with a leaping wireframe figure with right arm raised and right leg bent at the knee...

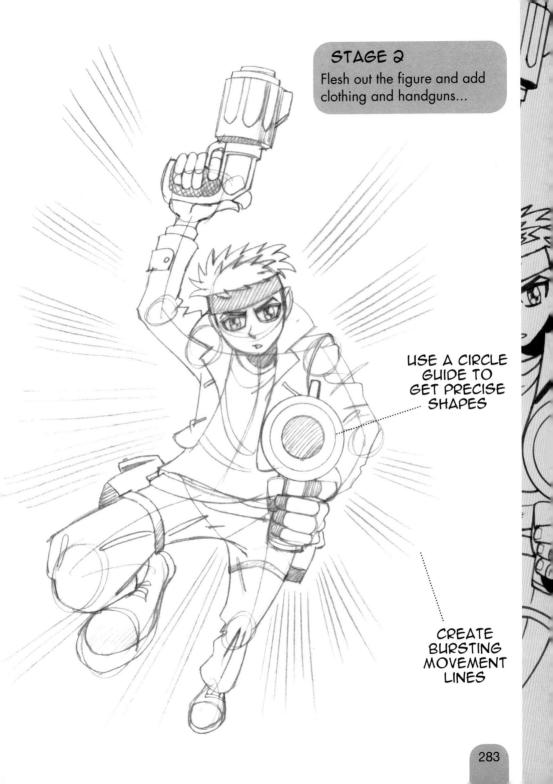

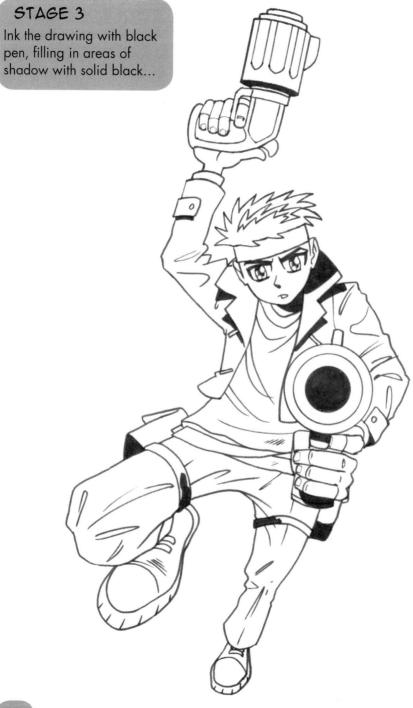

67,18

Add colour and shading to the character – draw in a few lines outside the character's arms and legs using paler tones to give a sense of movement.

INDEX

A

accessories 36–37 Adobe Photoshop 17 alien landscape 124–139, 234–249 anime 6, 7, 9 archery 168–85 art shop 14, 15, 16, 18

B

basketball 152–167 battle costume 47 blank page 19 brush 15, 16, 17 bunkobon 7

C

cartridge paper 15 cartridge pen 16 casket 186–201 circle guide 13, 18 close-up 250–263 clothing 35, 36 colour, colouring 16 compasses 13, 18 computer 16, 17 crackling energy 44–55, 56–71

D

desk lamp 12, 13 doodling 19 drawing aids 18

E

electricity bursts 140–151 emotions 28–29, 40–41 eraser(s) 13, 15 explosion 234–249

F

fabric 34 face 26 facial expression(s) 26, 28–29 features 27 figure(s) 22, 23, 24 flexi-curves 18 flying 234–249 flying combat 218–233 flying vehicle 124–139 foreshortening 100–113 futuristic agent 124–139

G

ghoul attack 72–85 graphic stories 6 graphic symbols 40–41 guard 114–123 gun(s) 37, 124–139, 280–285

н

hair styles 30–31, 36 hands 32 hero 44–55, 100–113, 250–263 heroine 114–123, 140–151

impact burst 130 impact lines 44–55, 72–85, 140–151 ink, inking 15, 16 ink-based pen 15, 16

J

jumping 114-123

L

layout pad 15 leaping 44–55, 86–99, 140–151, 152–167, 280–285 library 21 light 38–39 lightbox 15, 17 light source 12, 38–39

M

mangaka 6, 7, 16 manga genres: Magical Girl or Mahou Shojo 10 Mecha 8, 10, 218, 264 Mystery 11

Seinen 10 Shojo or Shoujo 10 Shojo Ai 11 Shonen or Shounen 10 Shonen Ai 11 Sports 11, 153, 202 manga paper 15 manga titles 10–11 marker(s) 12, 13, 15, 16 marker pad 15 martial arts 140-151 mecha figure 218-233, 264-279 mecha war 218-233 mirror 12, 20, 27, 33 missiles 218-233 movement lines 86-99

0

ogre 44-55

P

paint 16, 17 white, bleed-proof 13 paper 15, 22 pen(s) 12, 13 pencil(s) 12, 13, 14, 15, 43 pencil sharpener 14 pencils, colour 13, 15, 16 perspective 24–25, 100–113 photographs 21, 37 power staff 44–55

R

radiation 186–201 reference material 12, 19, 21, 61 rescue 264–279 robot 140–151 ruler(s) 13, 18 running 72–85

S

shadow 38–39 shaman girl 56–71 Shonen Jump 6, 8 slam dunk 152–167 sound effects 7, 41 special effects 40–41 speed lines 41, 44–55, 100–113, 124–139, 152–167, 218–233, 234–249, 264–279, 280–285 sprinting 100–113 surfer girl 202–217 swordswoman 86–99 symbolism 7

T

tankobon 7, 13 techniques colouring 53-54, 69-71, 81-85, 95-99, 110-113, 122-123, 135-139, 148-151, 163-167, 177-185, 194-201, 212-217, 228-233, 244-249, 259-263, 275-279, 285 colouring on computer 114-123 outlining with ink, inking 52, 65-68, 80, 93-94, 108-109, 121, 132-134, 147, 162, 176, 193, 211, 226-227, 243, 257-258, 274, 284 shading 55, 70-71, 82-85, 97-99, 111-113, 123, 135-139, 148-151, 166-167, 180-185, 200-201, 214-217, 229-233, 246-249, 261-263, 278-279, 285 sketching 46-51, 58-64, 75-79, 88-92, 104-107, 118-120, 127-131, 144-146, 154-161, 170-175, 188-192, 204-210, 220-225, 238-242, 252-256, 268-273, 283 wireframing 22, 24, 32, 33, 45, 48, 57, 74, 77, 87, 101–103, 116–117, 125-126, 142, 153, 159, 169, 187, 203, 219, 236-237, 251, 256, 265-267, 282 tentacles 56-71 throwing stars 37 tools 12, 14, 22 tracing pad 13

V

vanishing point 128, 237, 265

w

watercolour paint 17 watercolour paper 17 weapons 36–37 wireframe(s) see techniques, wireframing work space 12

GLOSSARY

Anime

Japanese animated productions, often based on popular manga series.

Bunkobon

Small-format paperback books that are collections of manga titles.

Cosplay

Costumed role play popular with many manga or anime fans.

Manga

Generic term for comics usually created in Japan, by Japanese artists.

Mangaka

Artist or creator of manga.

Otaku

Term used for devoted fans of manga, anime and related interests.

Shojo

Manga stories usually aimed at young girls (see page 10).

Shonen

Manga stories usually aimed at young boys (see page 10).

Shonen Jump

Best-selling manga magazine in Japan.

Tankobon

Generic name for collected manga works published in large volumes.

ACKNOWLEDGEMENTS

Thanks to Roz Dace, Juan Hayward, Becky Shackleton and Marrianne Miall at Search Press; to my sons Frank and Joe; to my pugs Leo and Maisie; to my local library in Truro for keeping a healthy stock of manga and comics in general to keep me reading; to Stan Lee and Roy Thomas for inspiring me to read, and John Buscema and Katsuhiro Otomo for making me want to draw. To all the amazingly talented and driven artists and writers who produce manga I would like to say *domo arigato*!

You are invited to visit: www.kaspar.co.uk http://keefsparrow61.tumblr.com www.facebook.com/keith.sparrow.1232